Ansel Adams

Ansel Adams

Edited by Liliane De Cock

Foreword by Minor White

A New York Graphic Society Book

Little, Brown and Company • Boston

LIBRARY OF CONGRESS CATALOGING IN PUBLICATION DATA

Adams, Ansel Easton, 1902-
 Ansel Adams.

 Reprint of the ed. published by Morgan &
Morgan, Hastings-on Hudson, N. Y.
 Includes bibliography.
 1. Photography, Artistic.
[TR653.A3 1977] 779'.092'4 76-53306
ISBN 0-8212-0721-0

New York Graphic Society books are published by Little, Brown and Company. Published simultaneously in Canada by Little, Brown and Company (Canada) Limited.

Printed in the United States of America

Fifth NYGS Printing, 1982

Many dates as given for the photographs are approximate.

10/13/83

809

To
BEAUMONT and NANCY NEWHALL,
dear friends and colleagues
for more than thirty years.

"Twelve photographs that matter in a year is a good crop for any photographer," Adams once said. And he meant what he said. In the present collection, scattered among the dozen-a-year images, are those which stem from his quietness before Nature and Humanity, thus warmth is added to Adams' customary public image.

Multi-talented Adams started out to be a professional pianist and teacher, but something went wrong, or maybe right, with him; he took up photography. From music, he brought to camera work long hours of practice. This accustomed him to technique and hard work; intense study of great composers led him to a deep sense of esthetics, also the direction of creativity required of a performing artist, which, interestingly enough, fit photography very well. When he changed media, musical art, perfection, and creativity were so much a part of his blood stream that he never had to explore these difficult equivalents in photography. He had only to master the new craft in order to express beauty and, thanks to daily practice disciplines, that was rapid. He entered photography as a performing artist and still sustains the role.

If photography and music are his major talents, writing is a third. So far as photography is concerned, his writing talent serves the craft

exclusively. When pressured, he begrudgingly writes on photographic esthetics (he says his photographs define that better); on the topics of picture content and images for self-study, he writes only warnings. While he admires what others do with the special medium of words *and* pictures in a single message of faith, he leaves the specialty to them. He believes with passion that photographs should stand alone and, in this respect, he reflects the painter's ideal of single images.

Speculations arise about men with multiple talents: why has Adams sought to keep music, photography and writing rather separated when he might have integrated them as, for example, in film? He says, "It is a matter of emphasis." Keeping his music as a private expression for family and friends could be explained easily. Music was something he fortunately achieved before reaching the esthetic of photography that has sustained him and by which he, in turn, has sustained the art of photography. The separation he maintains between fine photographs and poetry, suggests to me, at least, to look for causes. Perhaps the fact that he was trained to be a performing pianist rather than a composer is a potential reason. This potential must be balanced: just as he might write poetry for his

photographs, he might have been a composer. In fact, he did a little composing.

Speculations aside, the present monograph broadly represents Adams, the photographer. We see him invest straight photography with a princely quality rare in any medium. We see him stylistically sign his images with a flourish of light and three-dimensional depth. Nature never seems so grand, romantic, sensuous, and magical elsewhere, nor the buildings so architectural, nor the artifacts of man and details close to the ground so full of presence. We find his portraits celebrate the dignity of men, women and children whatever their status in life. We find, if we gaze long enough, that behind his more literal images ("superior postcards," as some say they are) there rests a sense of awe before creation, life and death, man and nature. Ordinary journalism alone escapes his camera.

Sequestered within his total work, intense silent images resound with love of the kind his youthful fingers made, when he played piano.

We see how he uses superb craftsmanship to express excitement, awe and wonder. He is a prime exponent of those who make of craft an elegant expression of art. "Just right" for Ansel is the moment of transformation on the ground-

glass or the viewfinder of the small camera. For Adams, the transformation of Nature to Image always clarifies and reveals that "spirit" is more precise than the sharpest lens.

Minor White
Arlington, Massachusetts July 1972

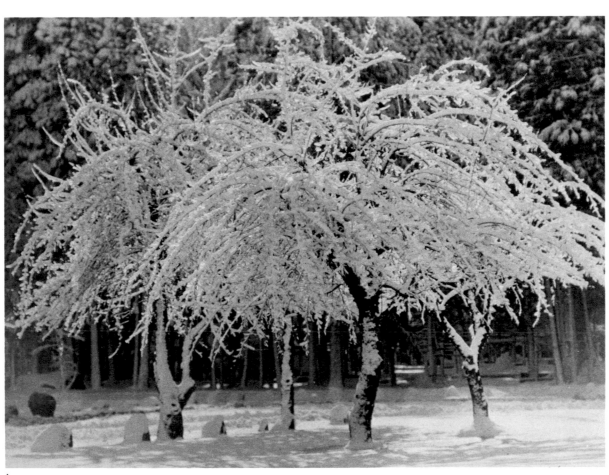

1

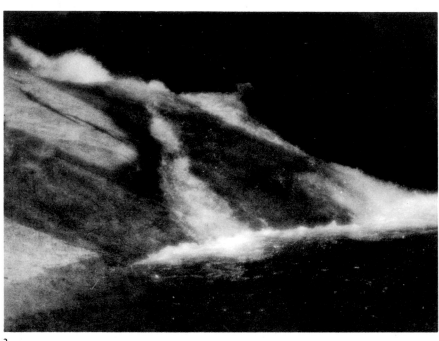

2

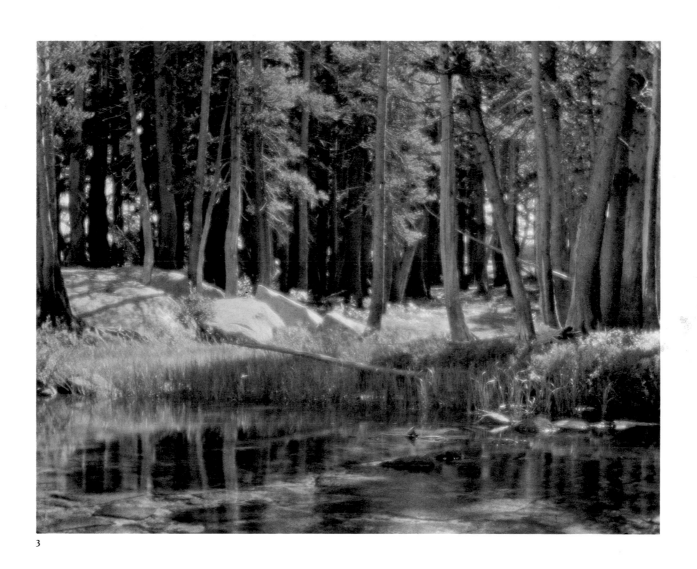

3

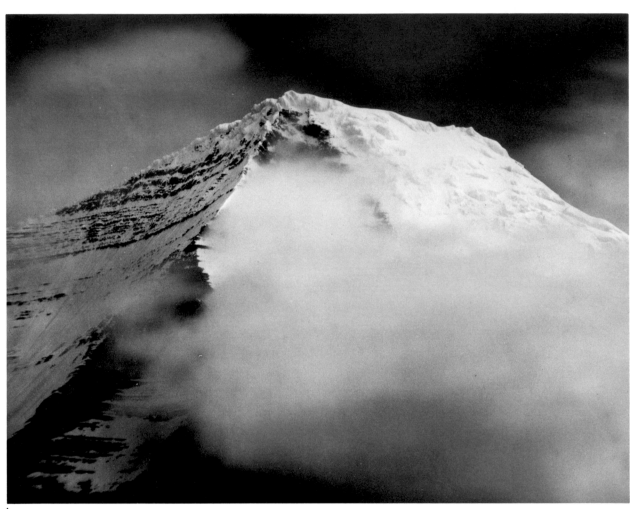

4

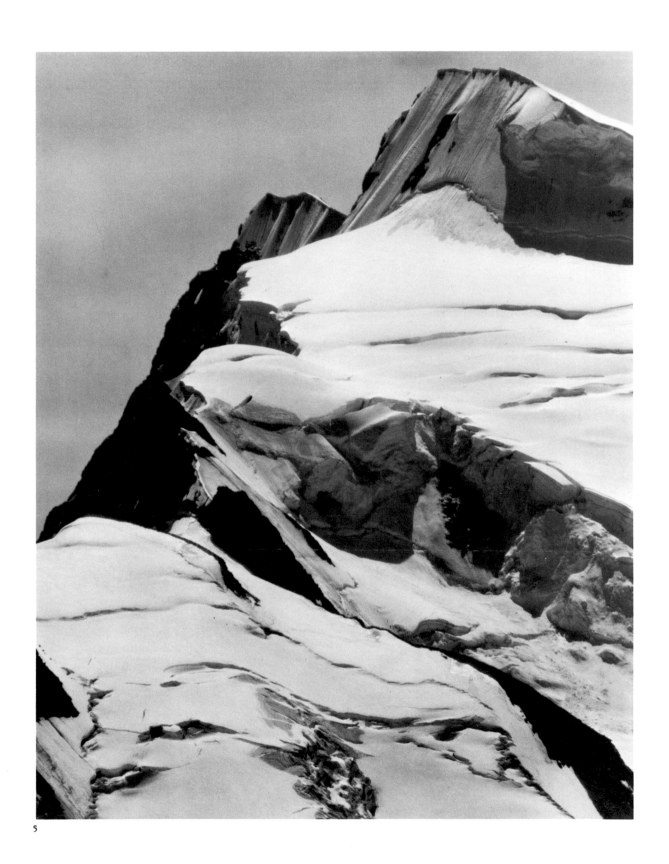

5

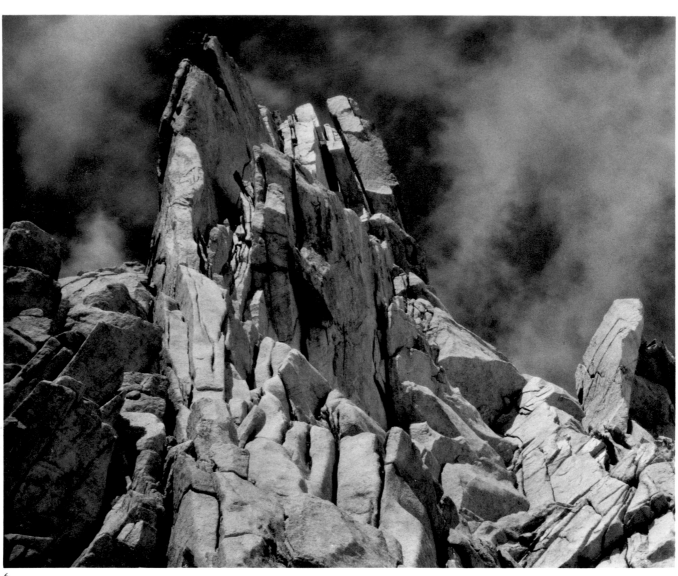

6

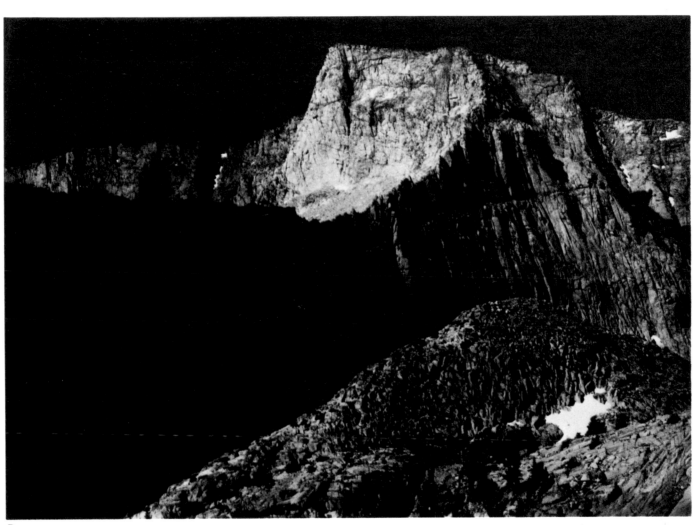
7

8 Monolith, the Face of Half Dome, Yosemite
National Park 1927

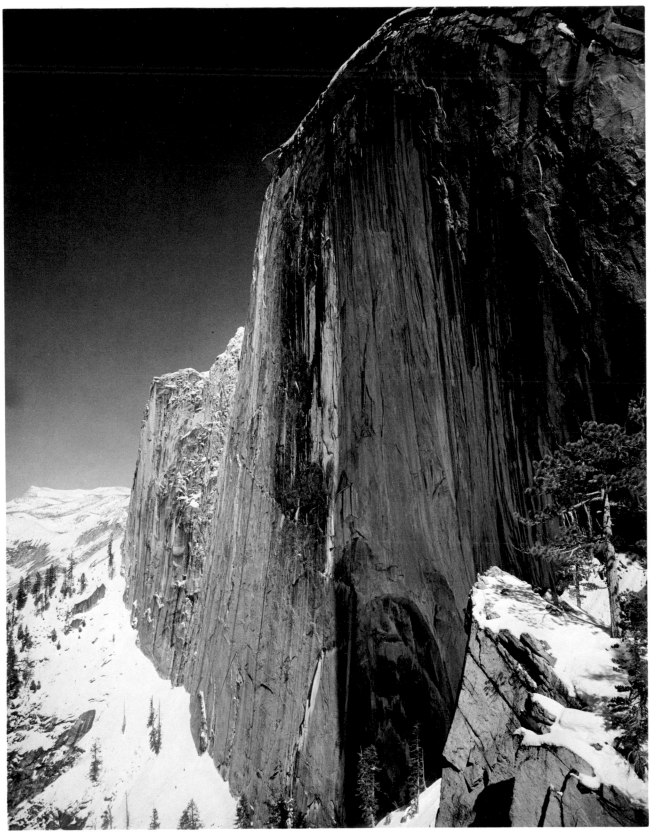

8

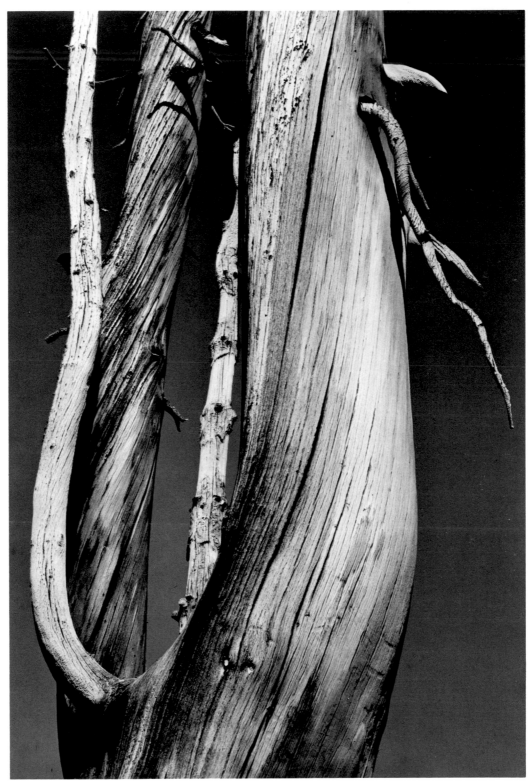

9

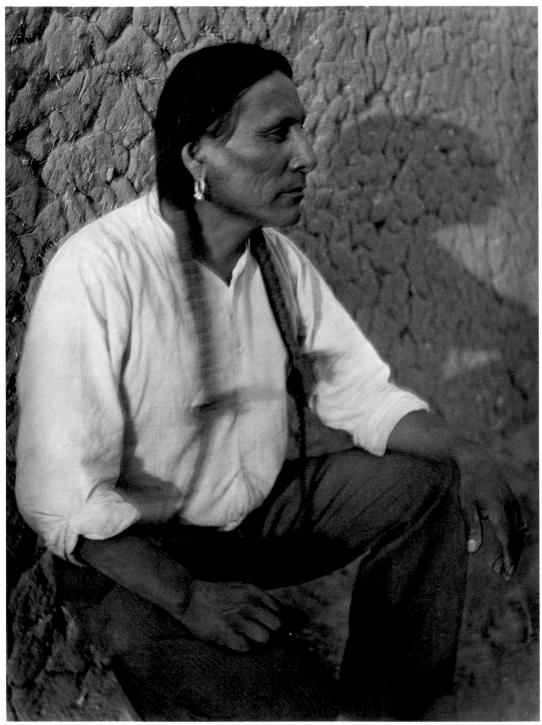

10

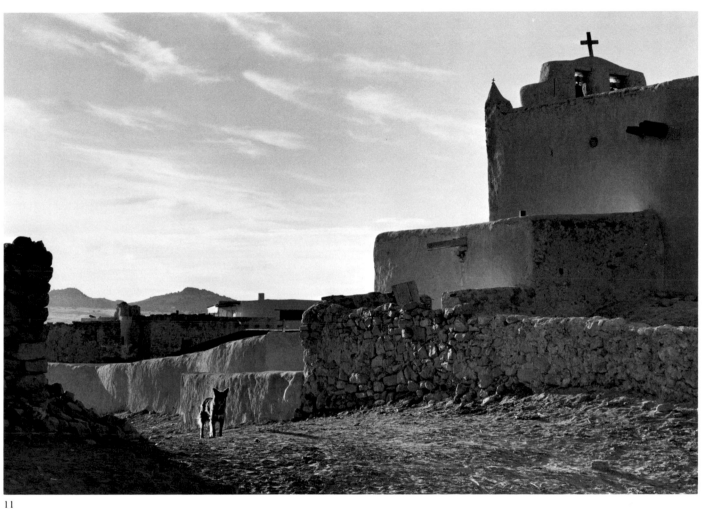

11

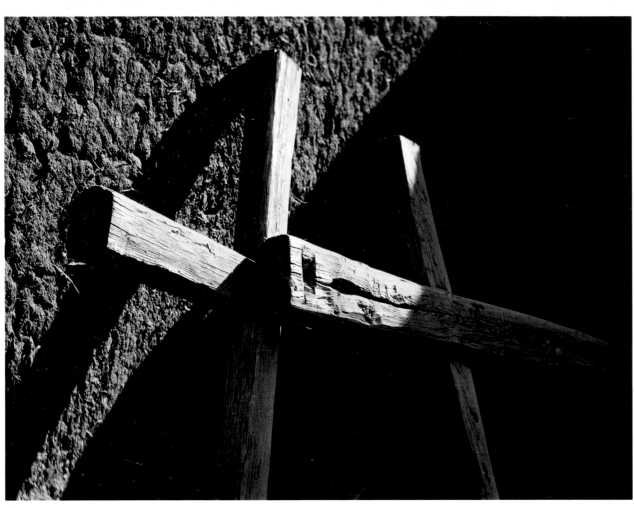

12

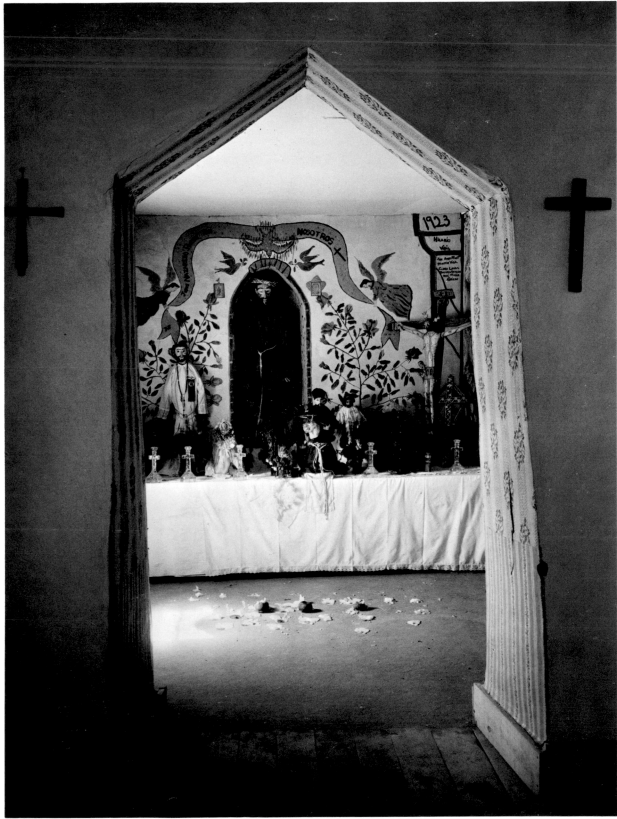

13

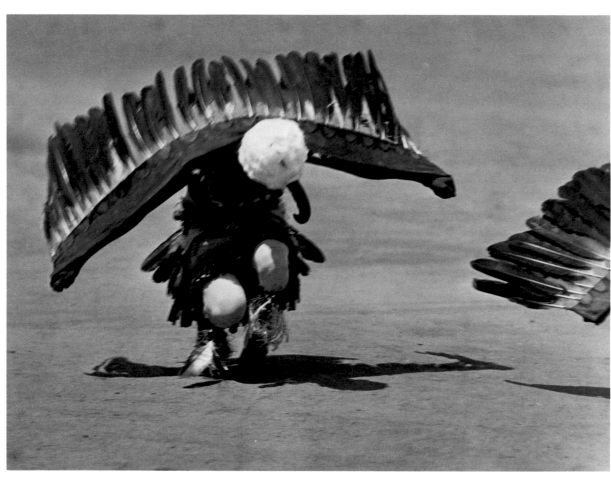

14

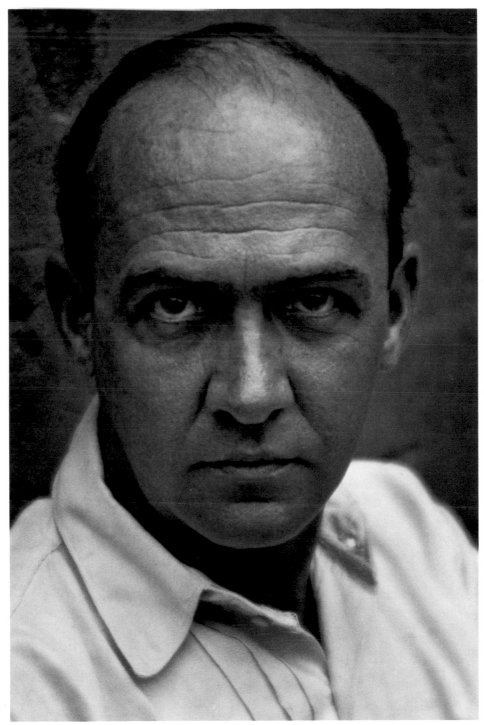

15

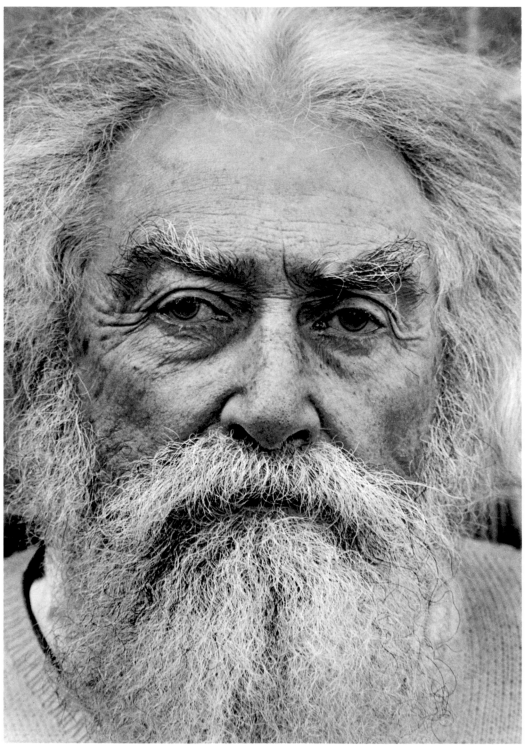

16

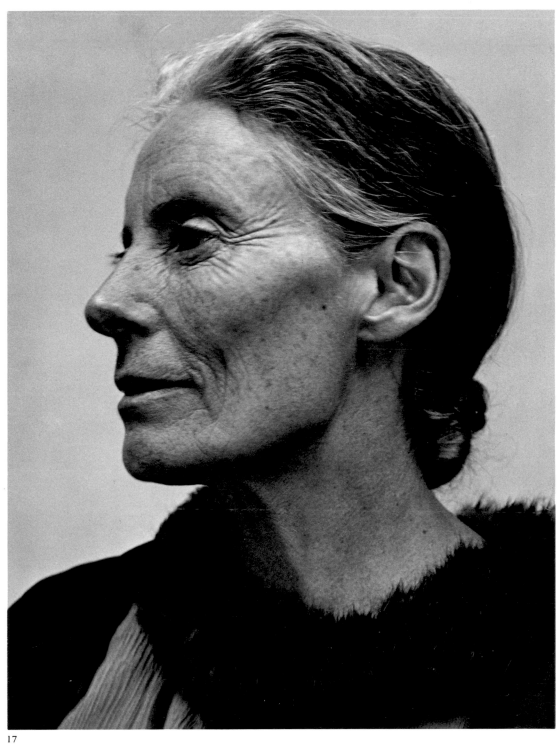

17

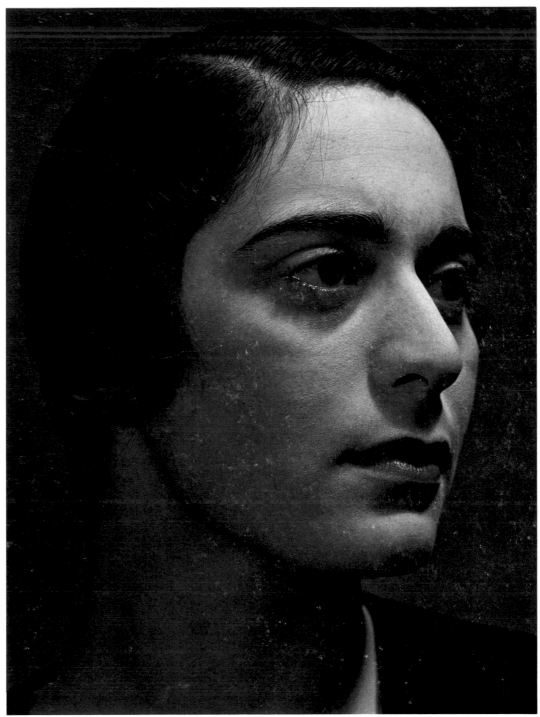

18

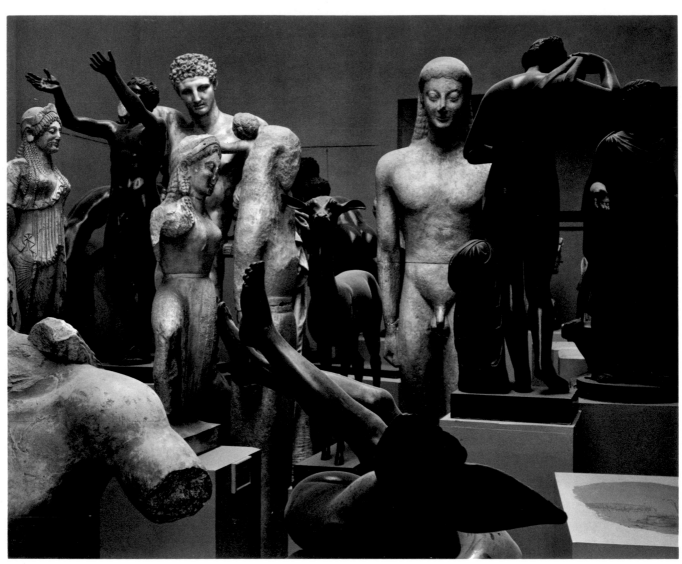

19

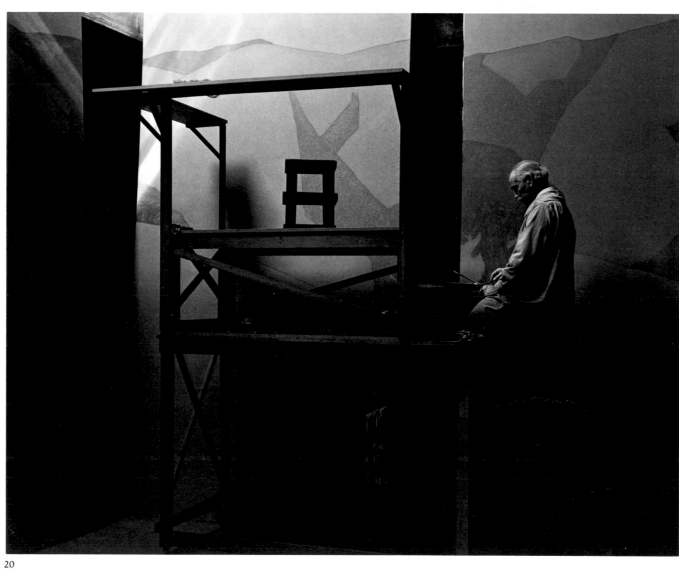

20

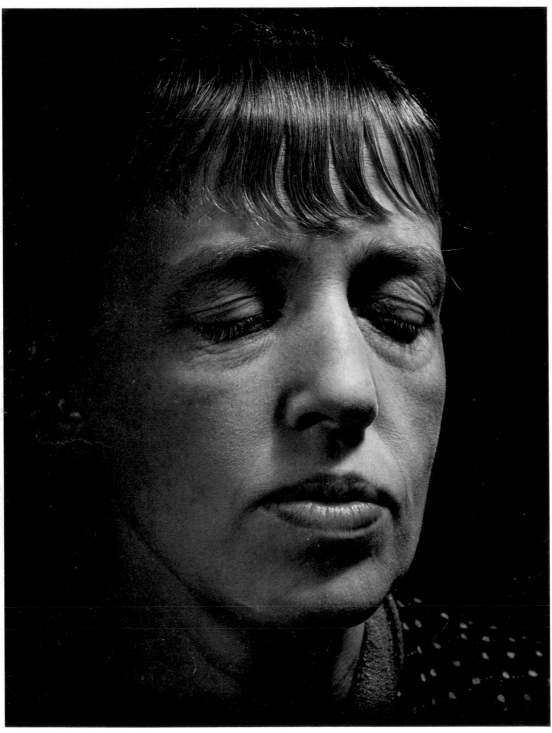

21

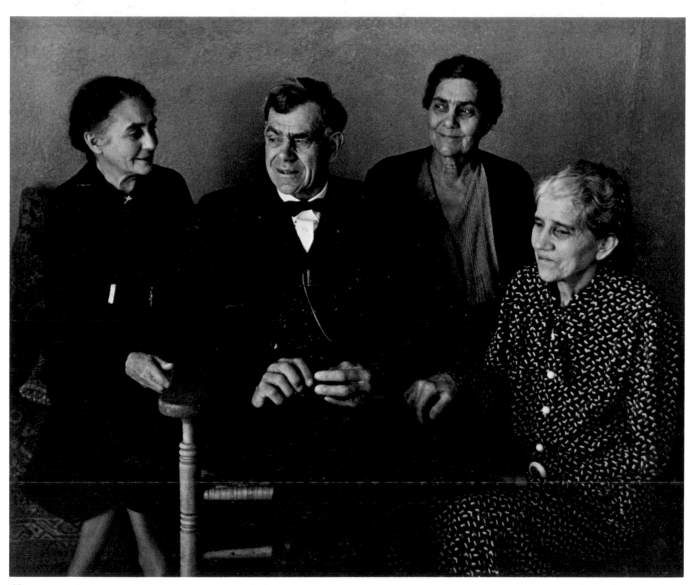

22

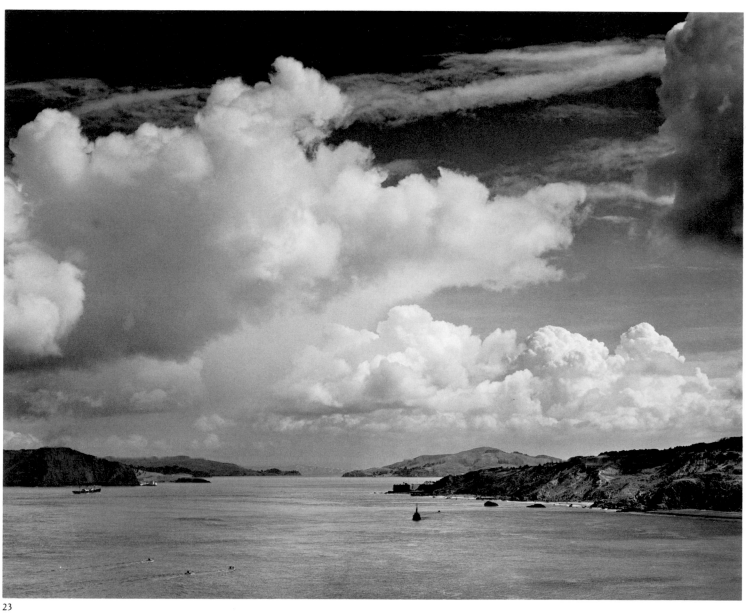

23

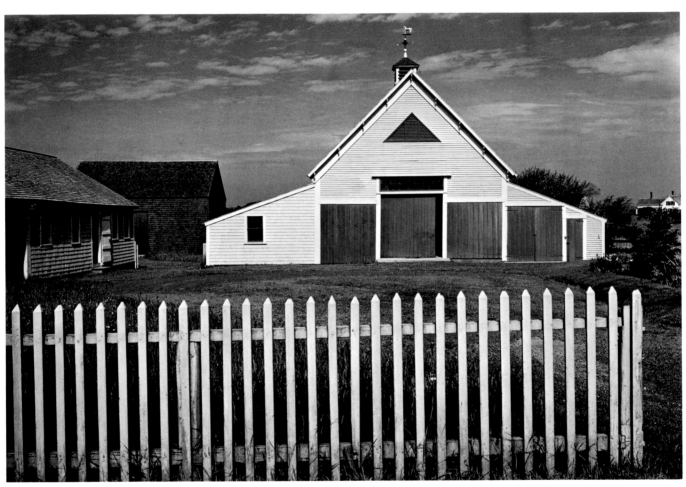

24

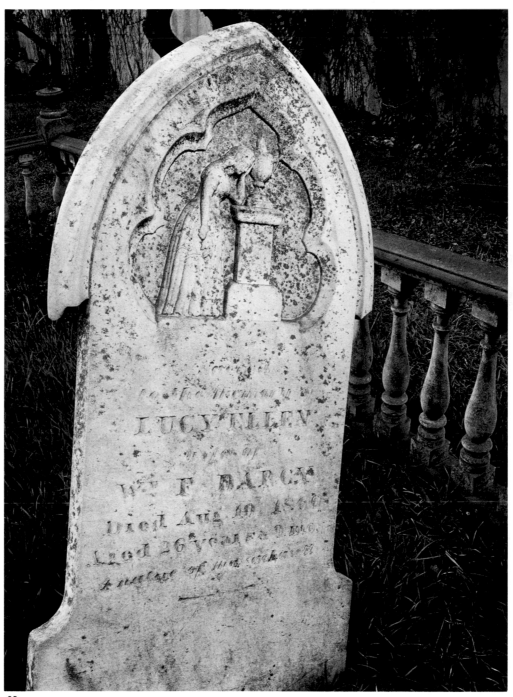

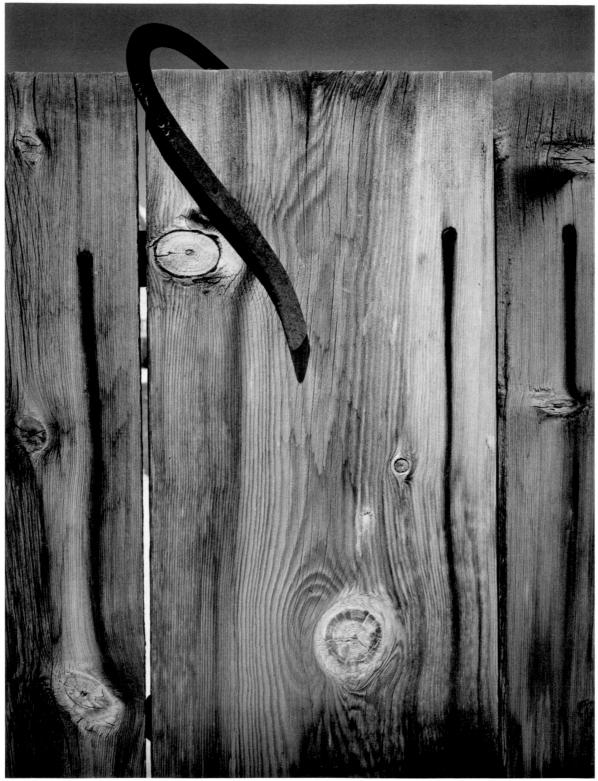

26

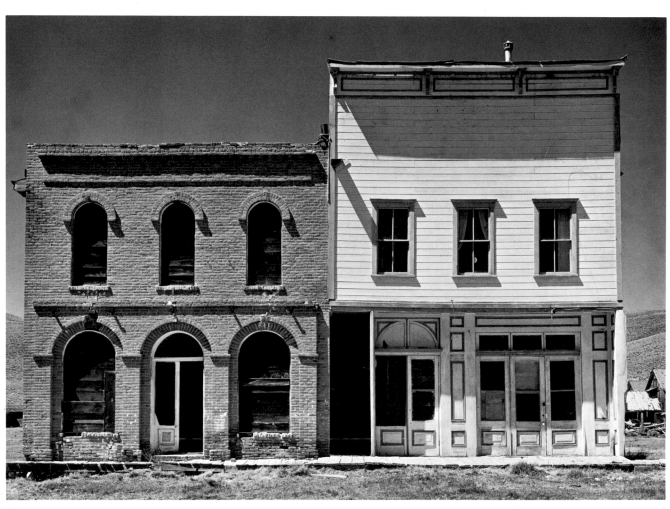

27

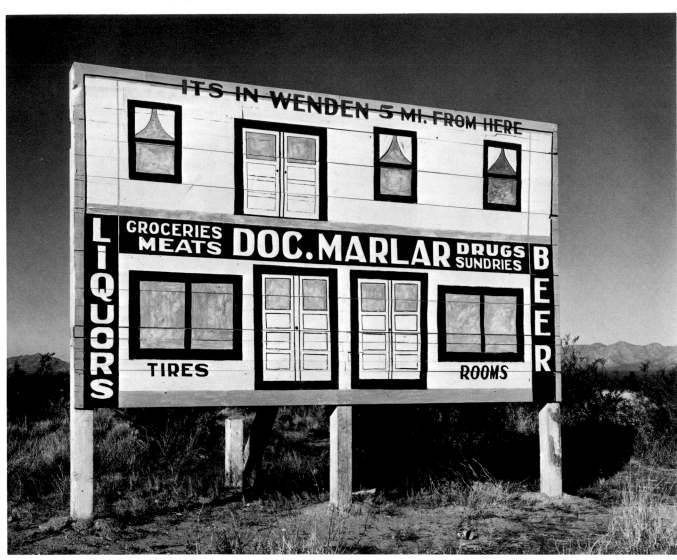

28

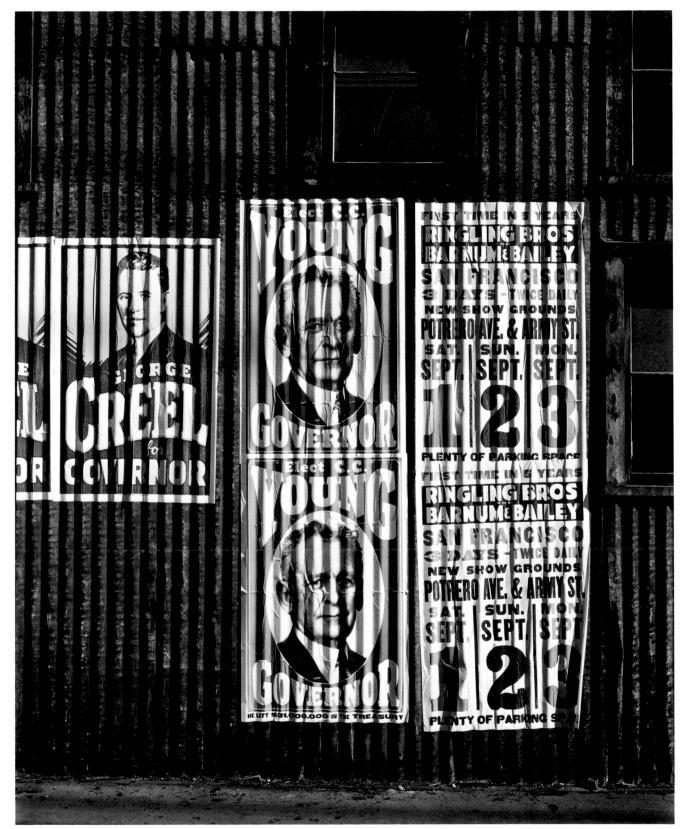

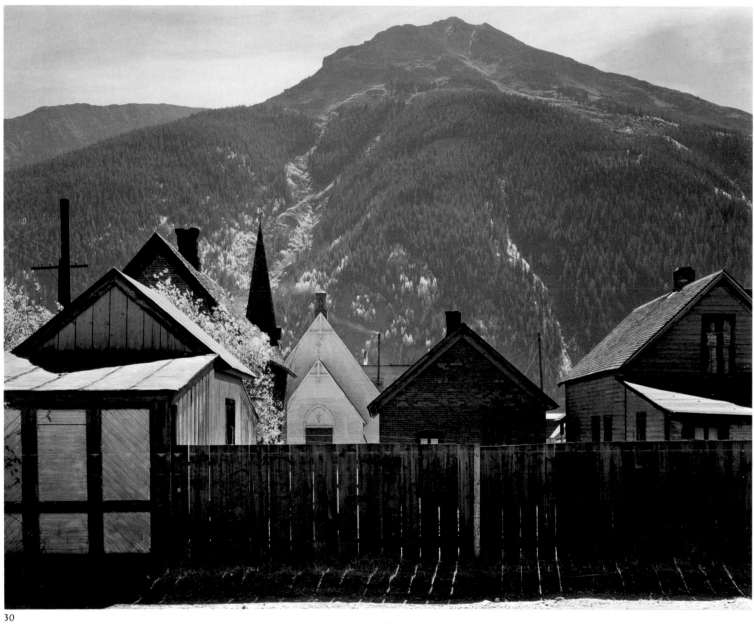

30

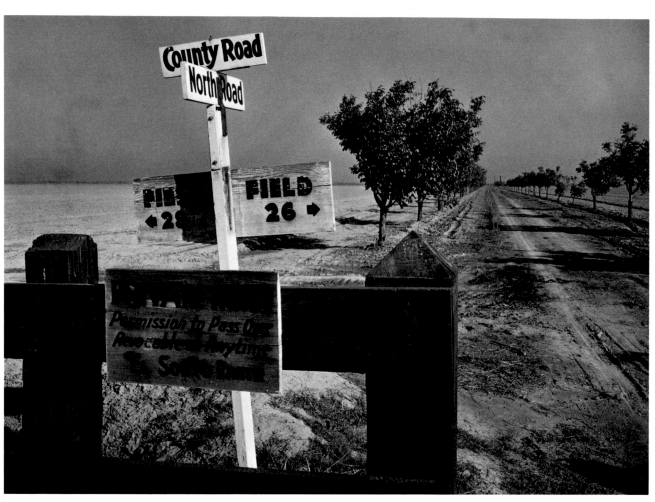

31

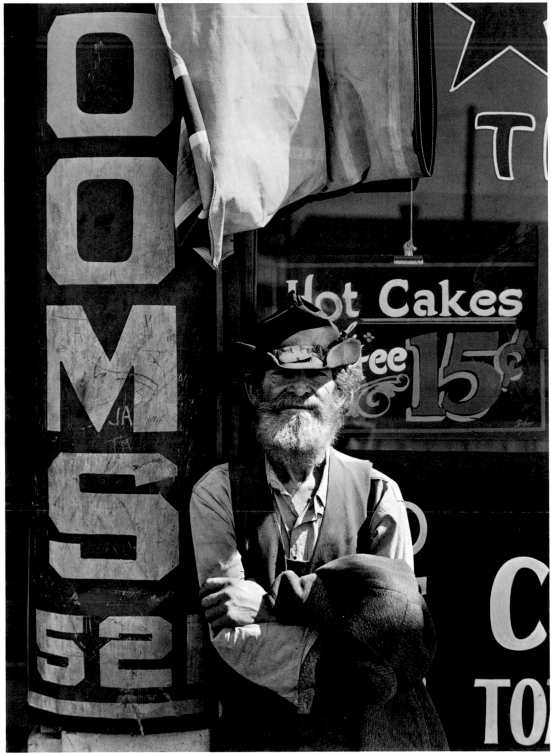

32

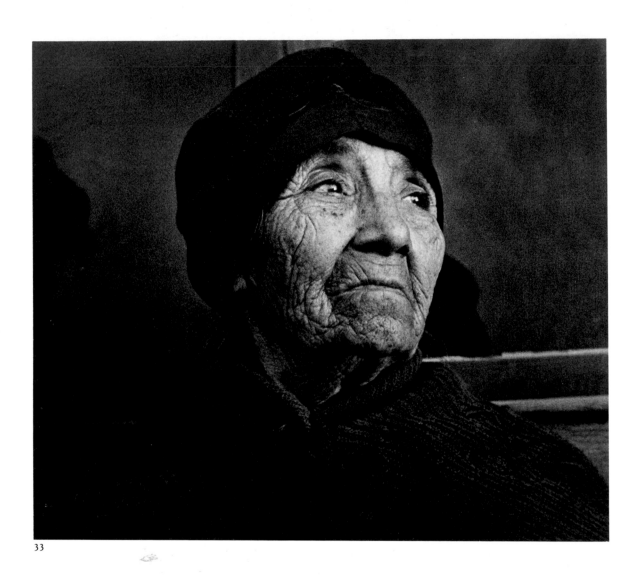

33

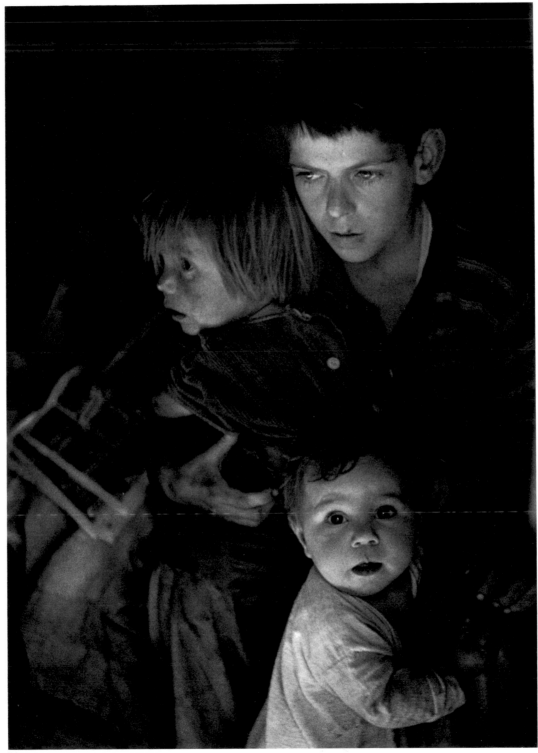

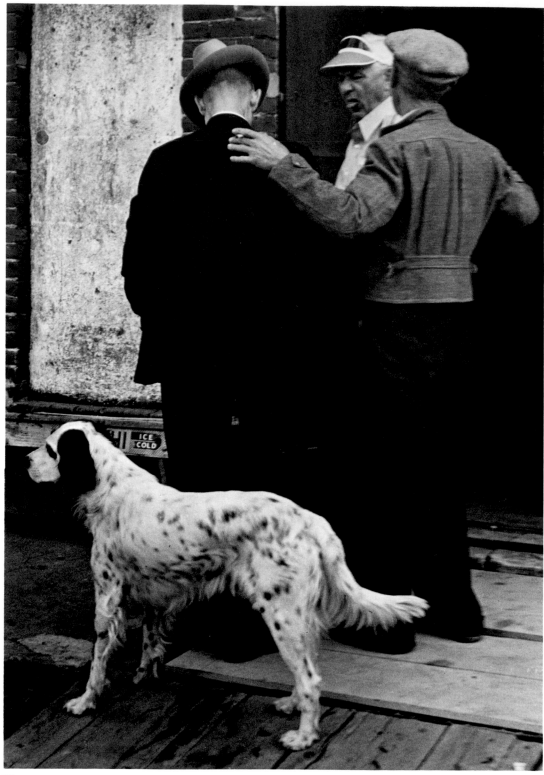

35

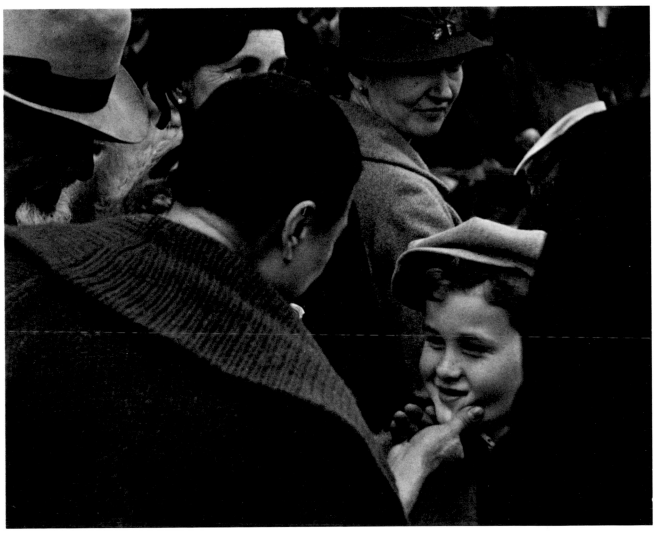

36

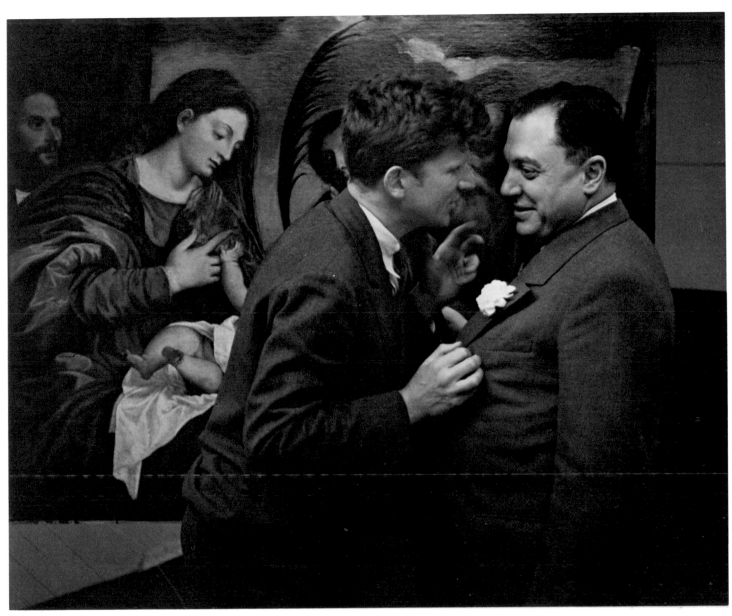

37

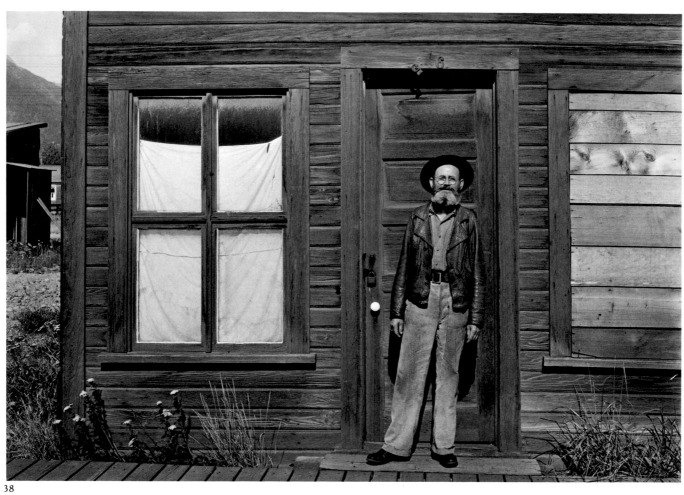

38

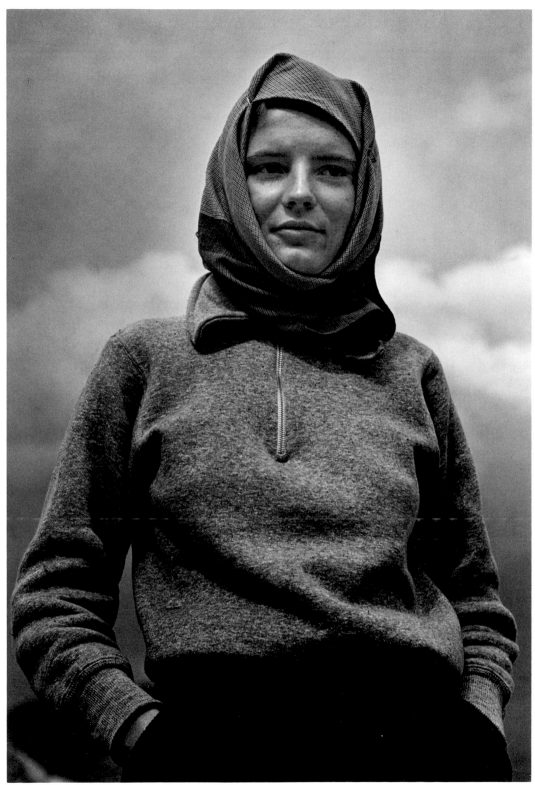

39

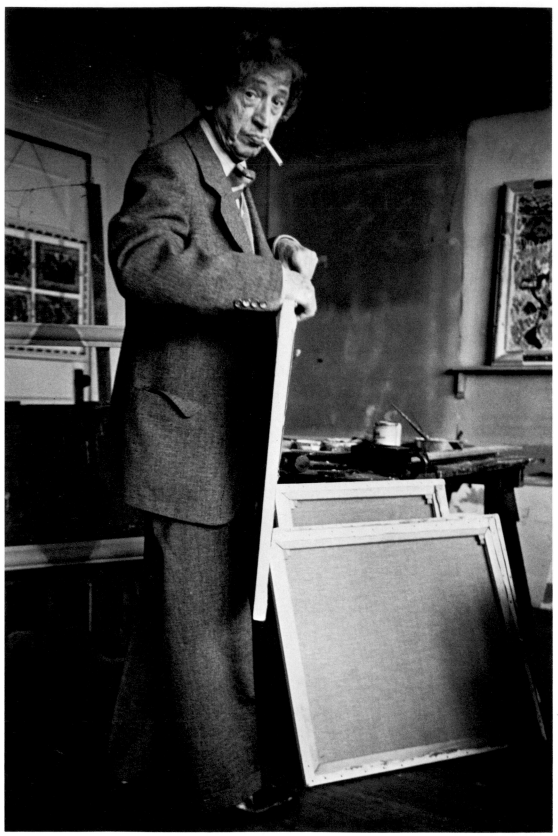

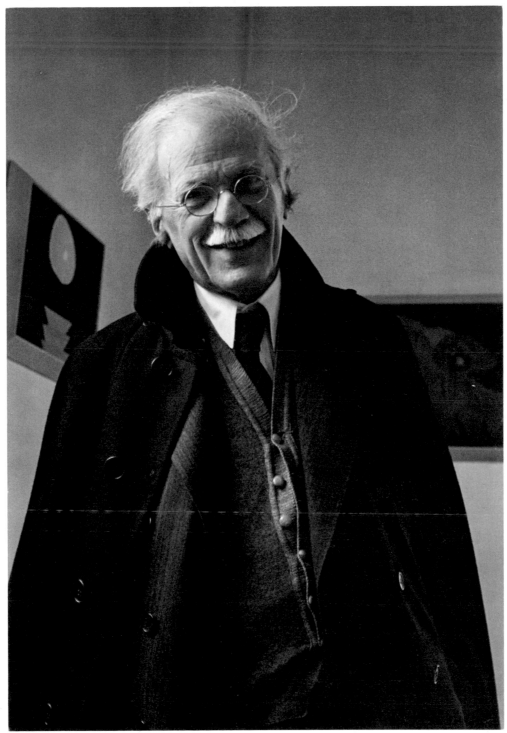

41

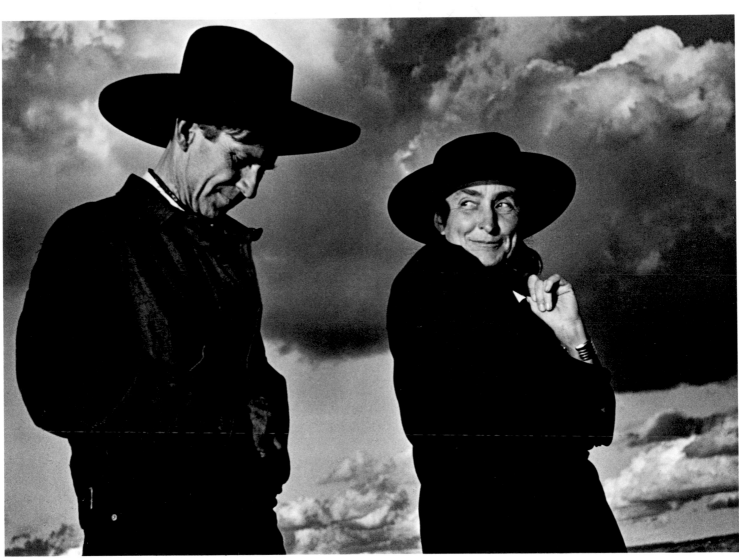

42

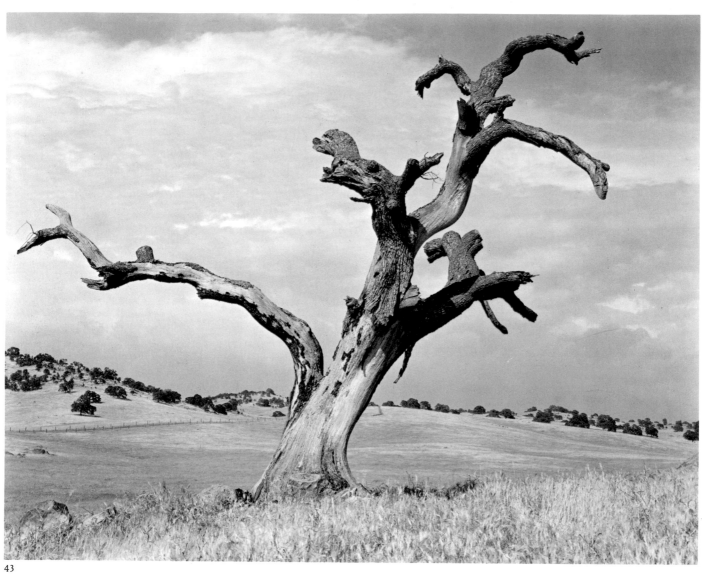

43

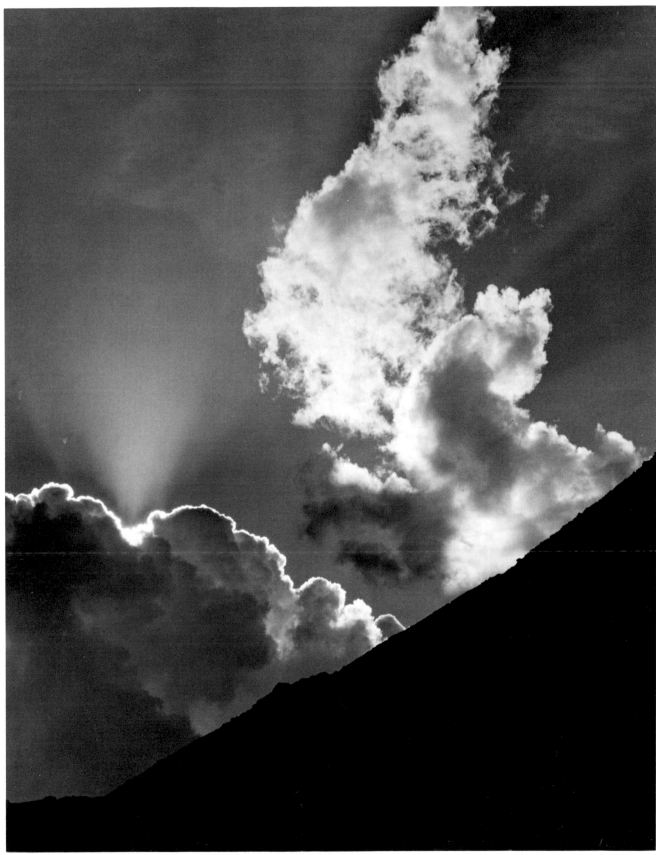

44

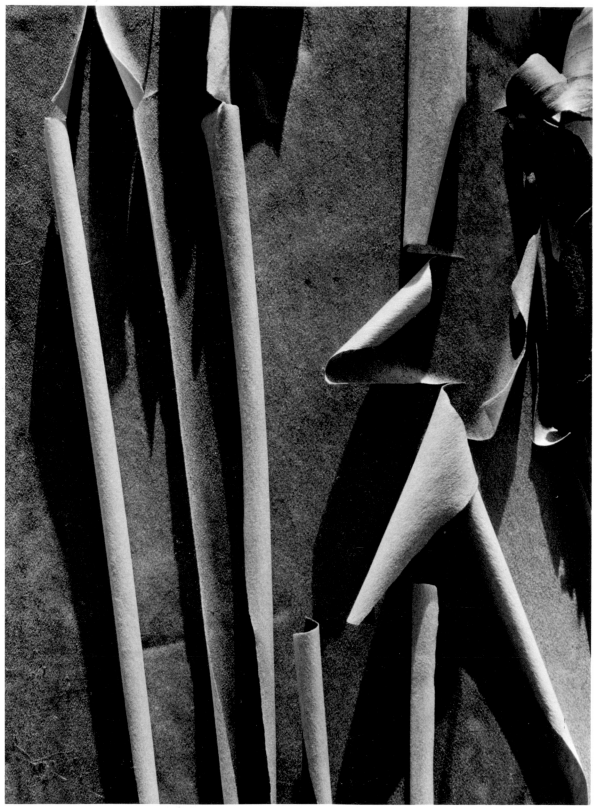

45

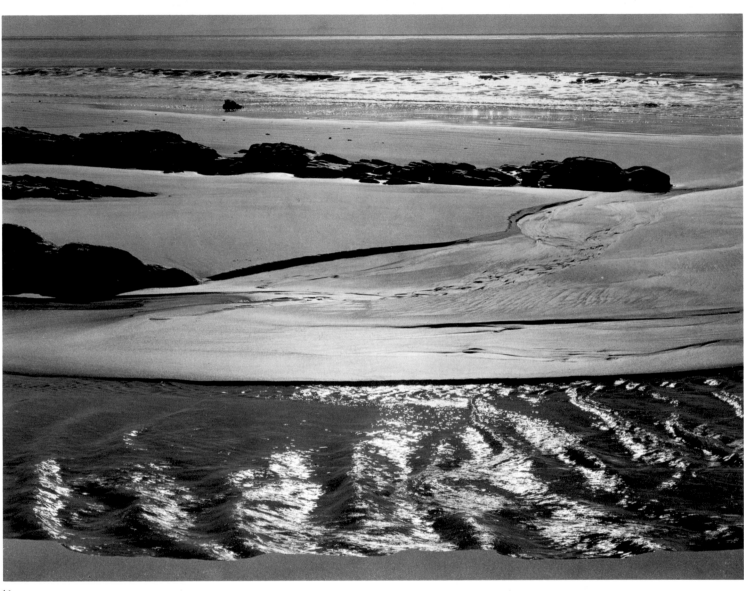

46

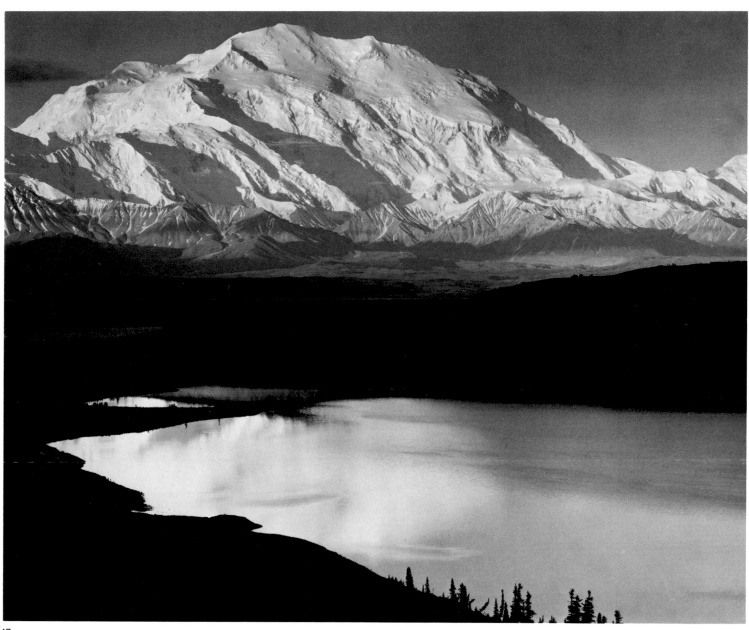

47

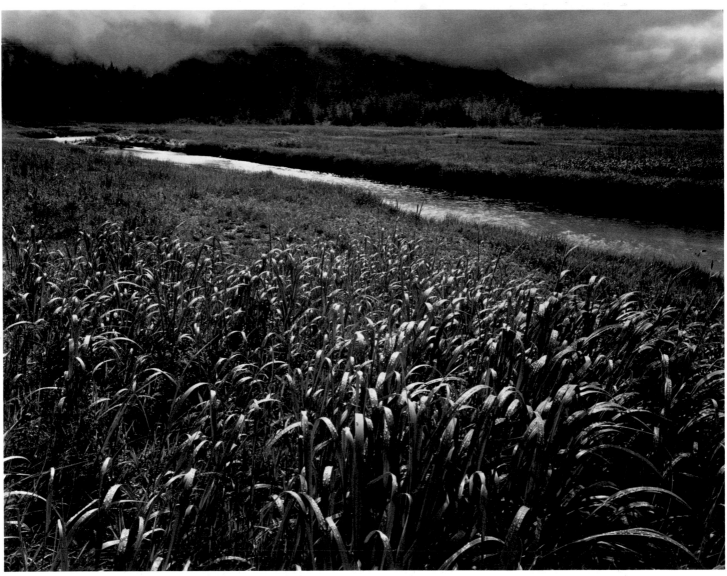

48

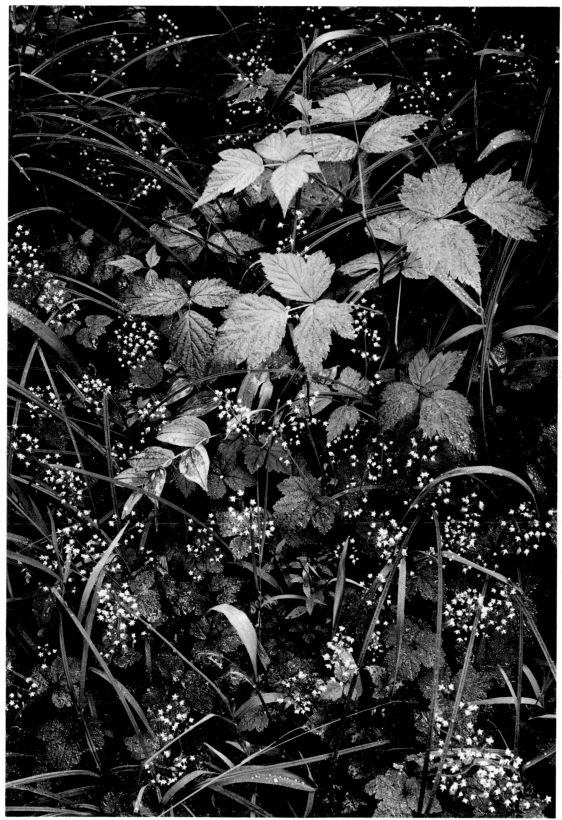

49

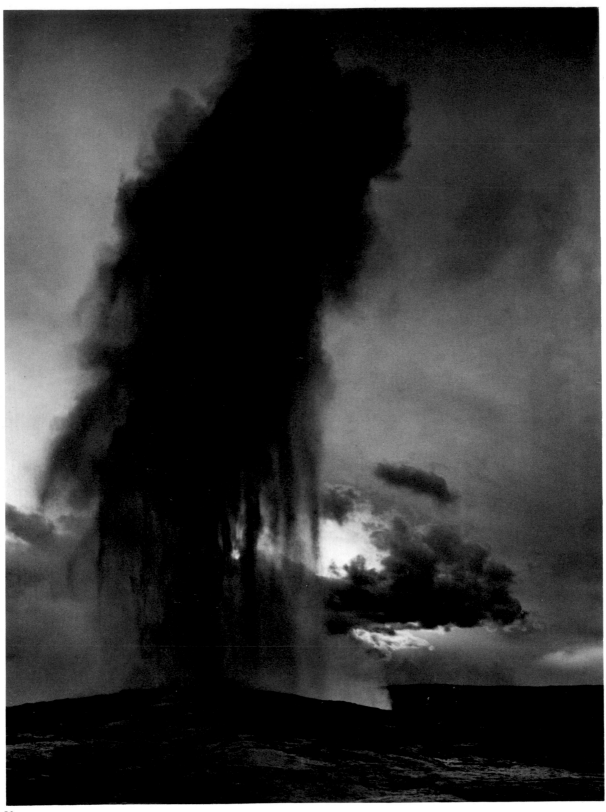

50

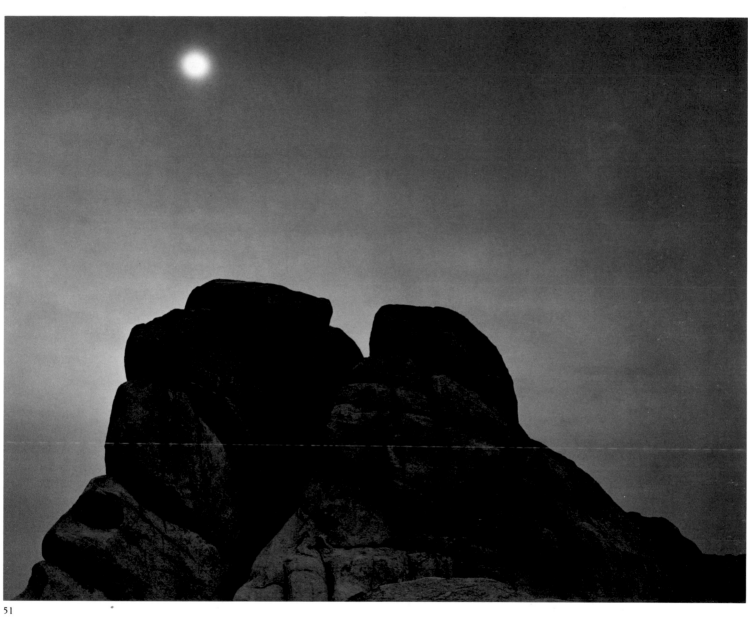

51

52 Sunrise, Dunes, Death Valley National
 Monument 1948

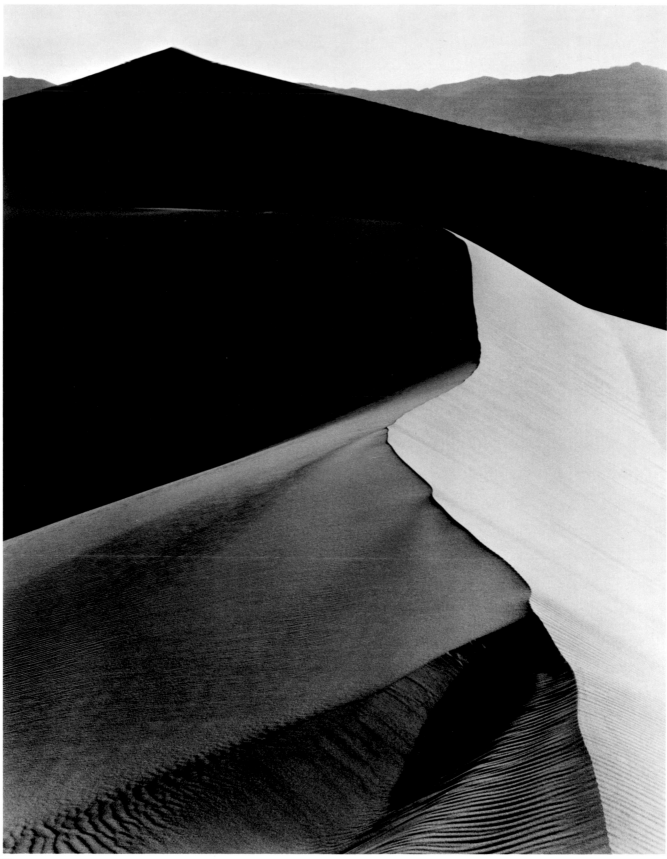

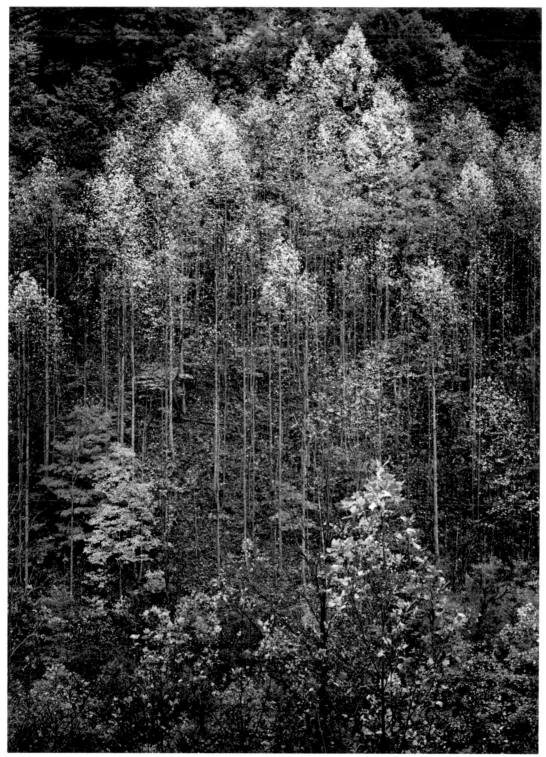

53

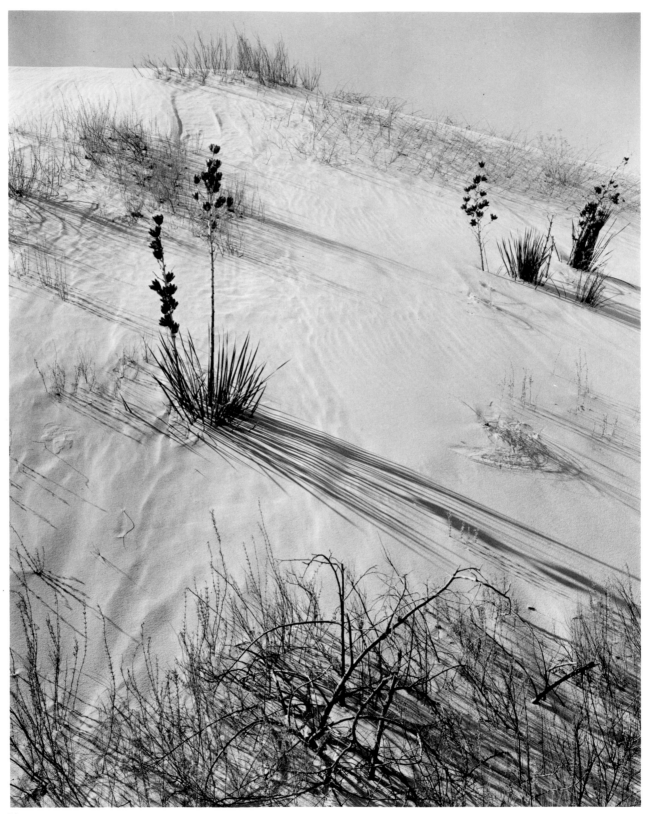

54

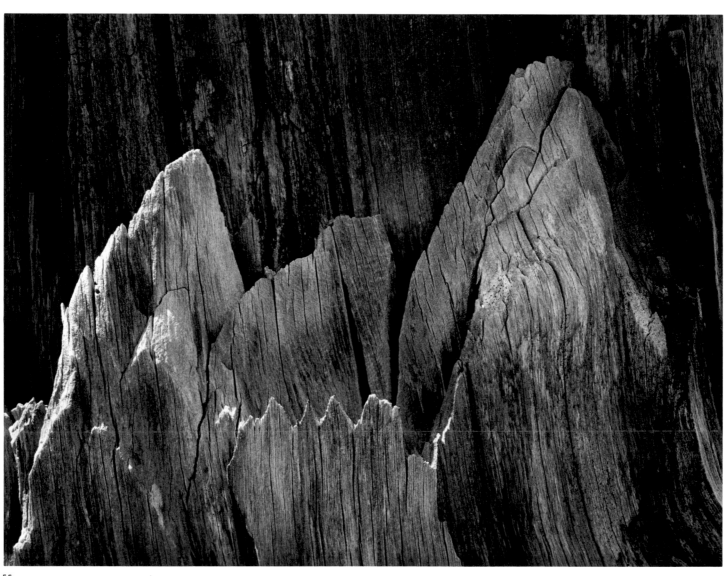

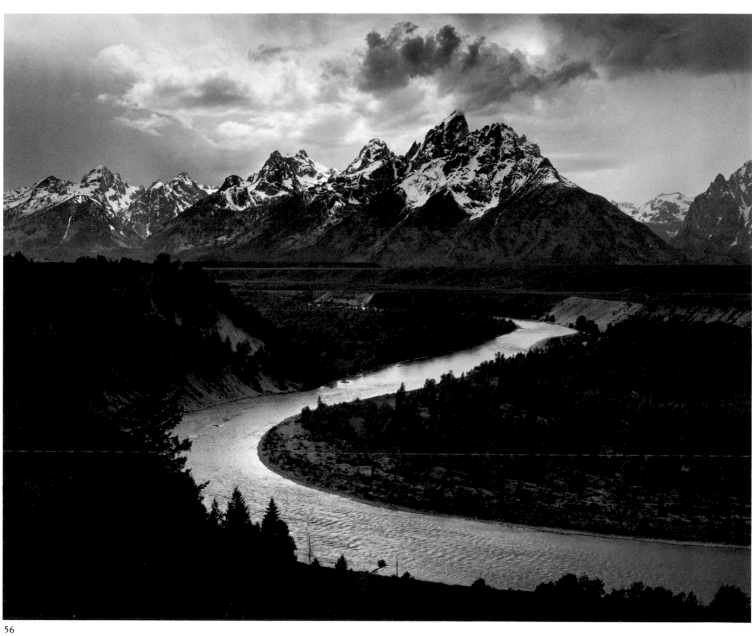

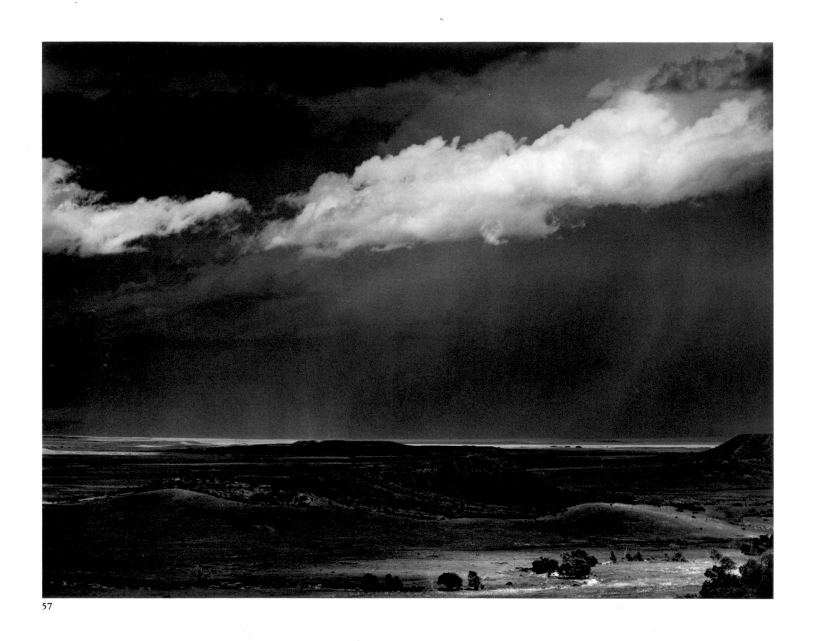

57

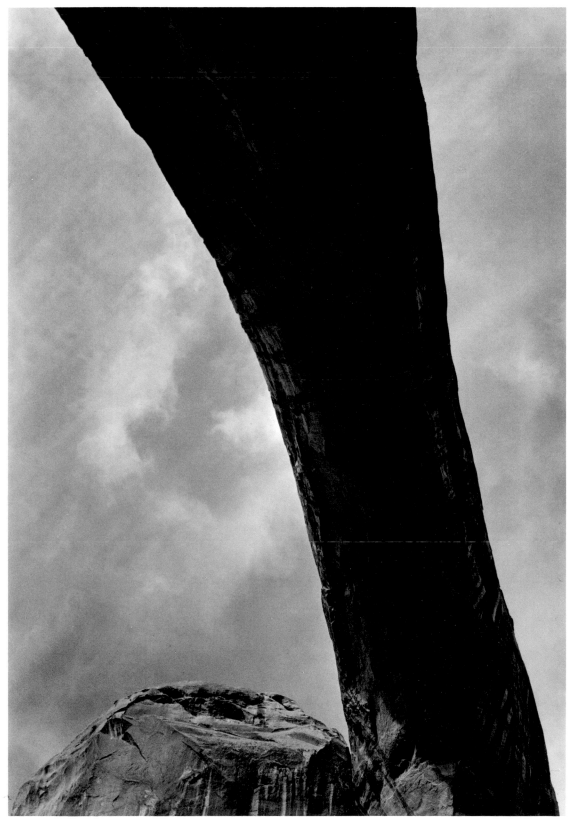

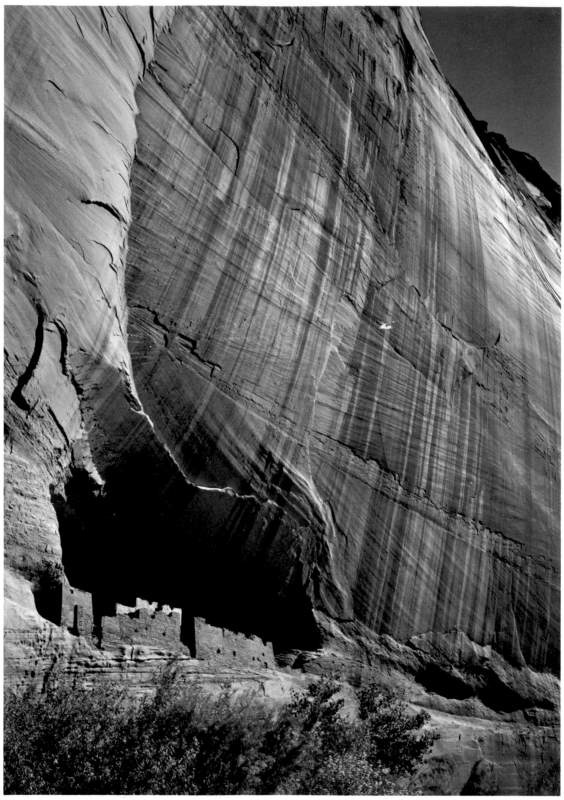

59

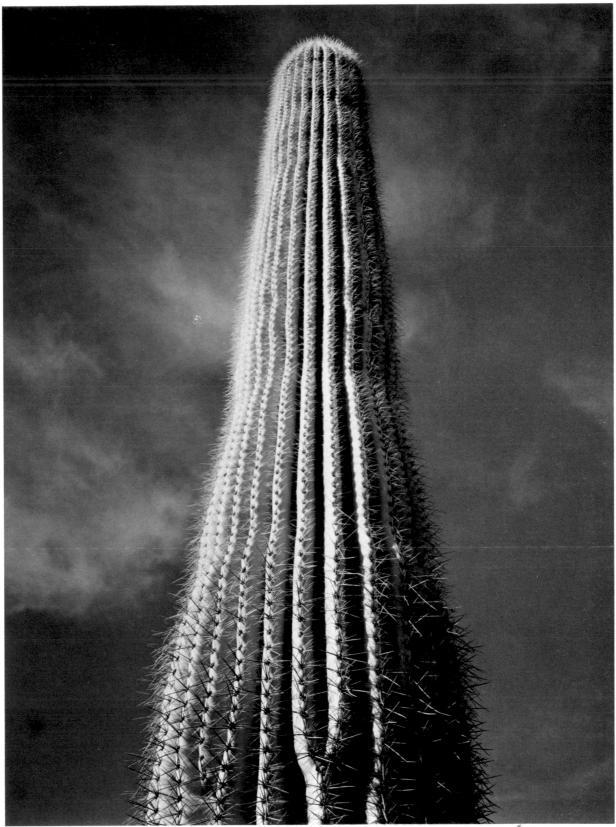

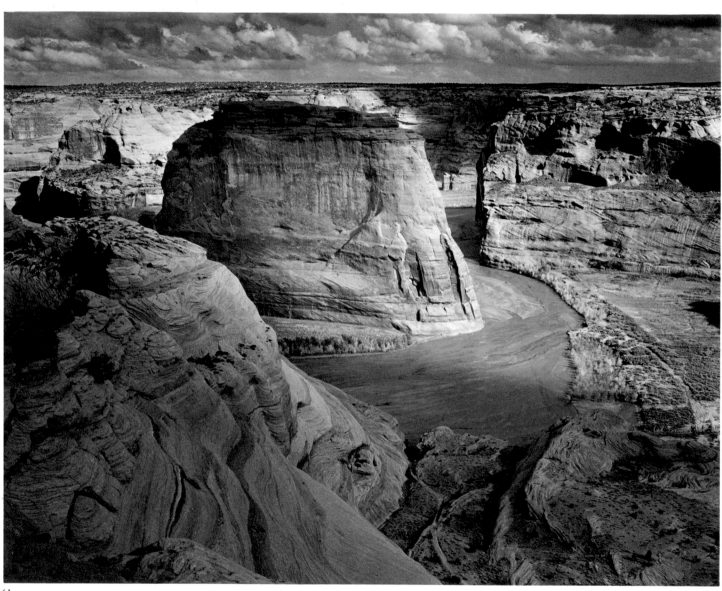

61

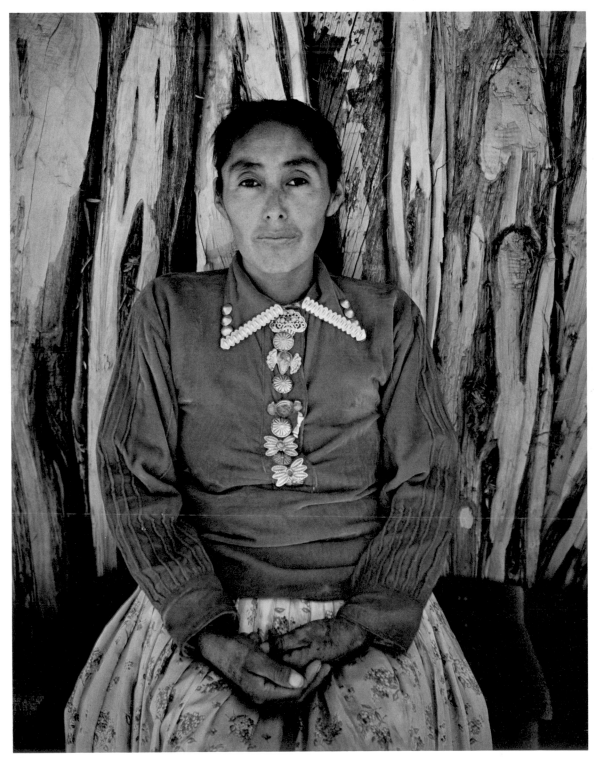

62

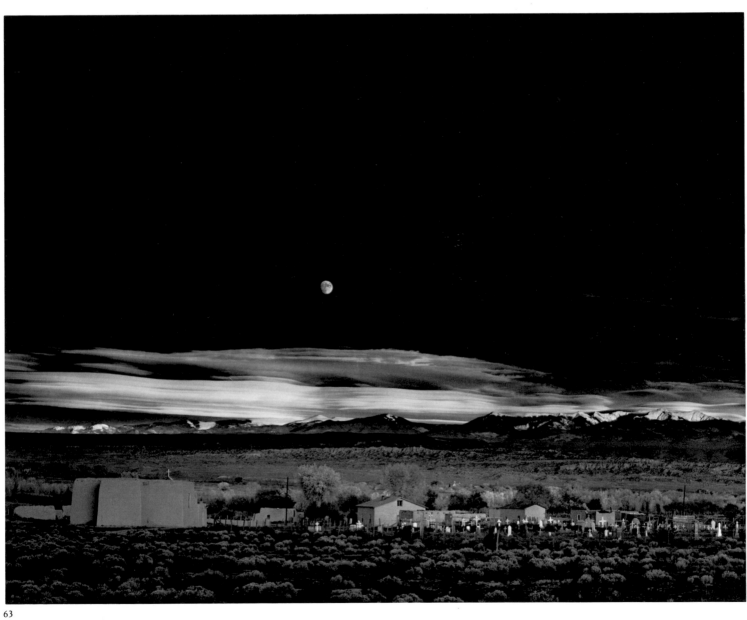

63

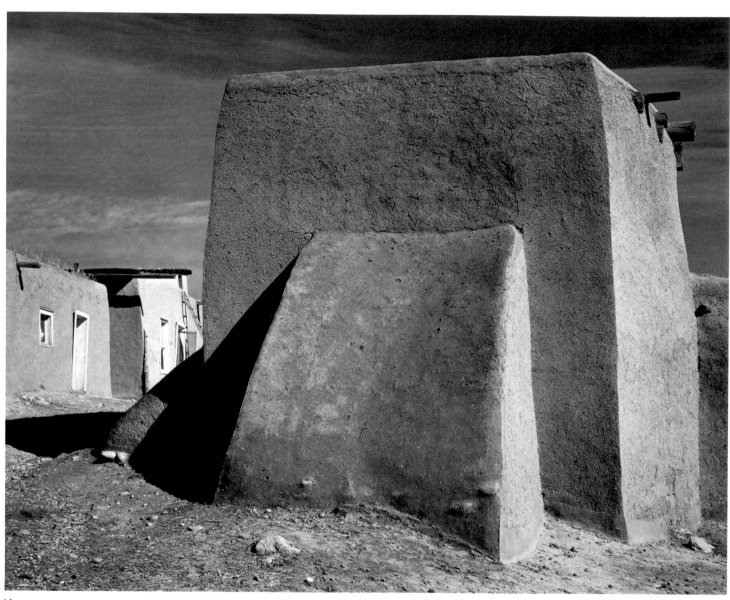

64

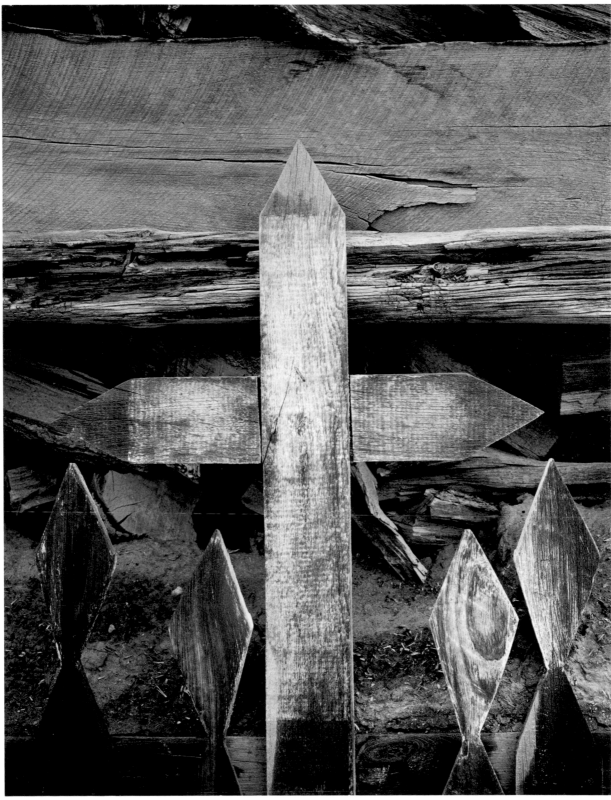

65

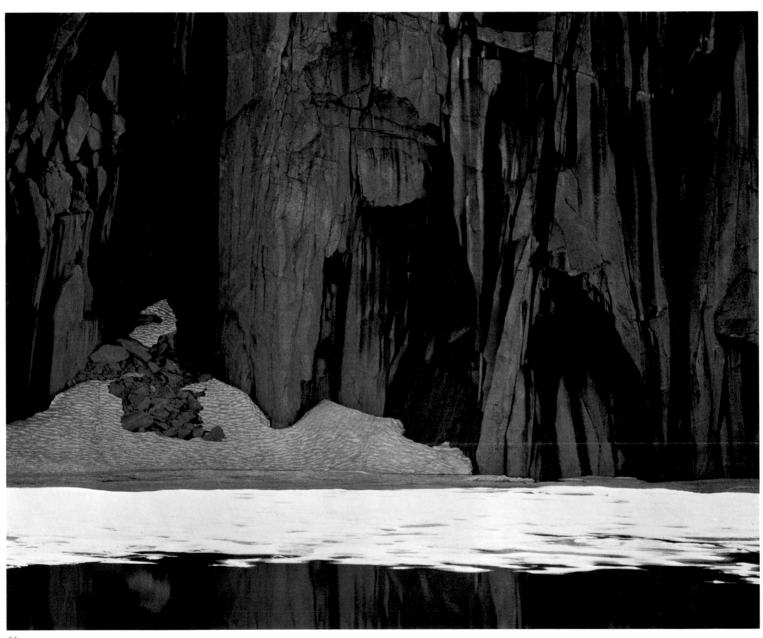

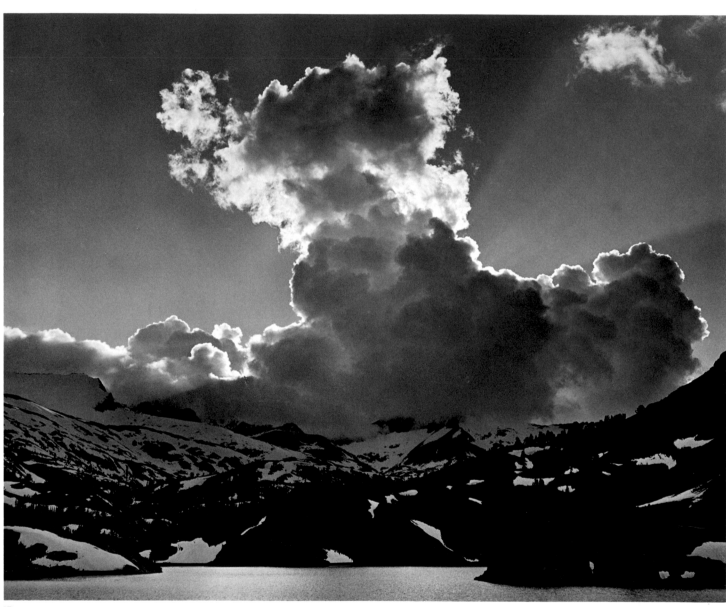

67

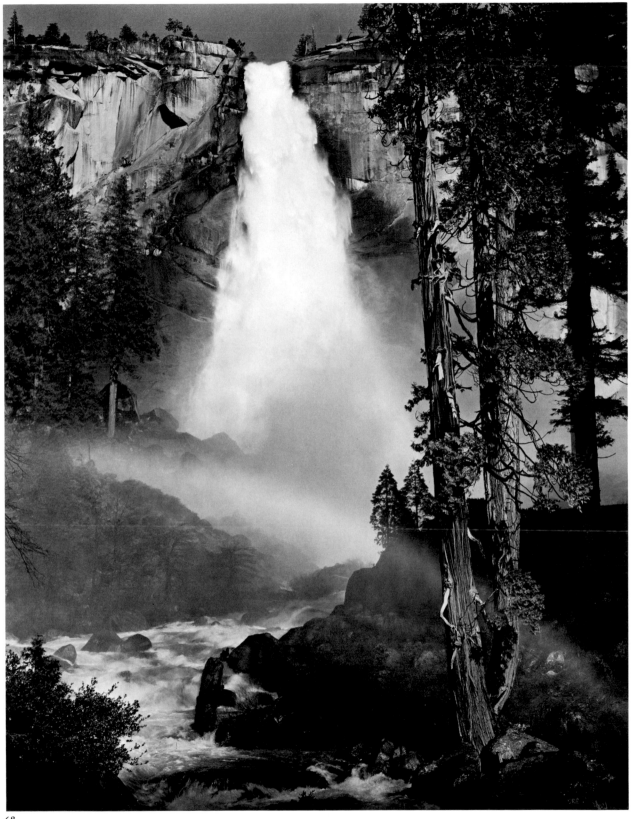

68

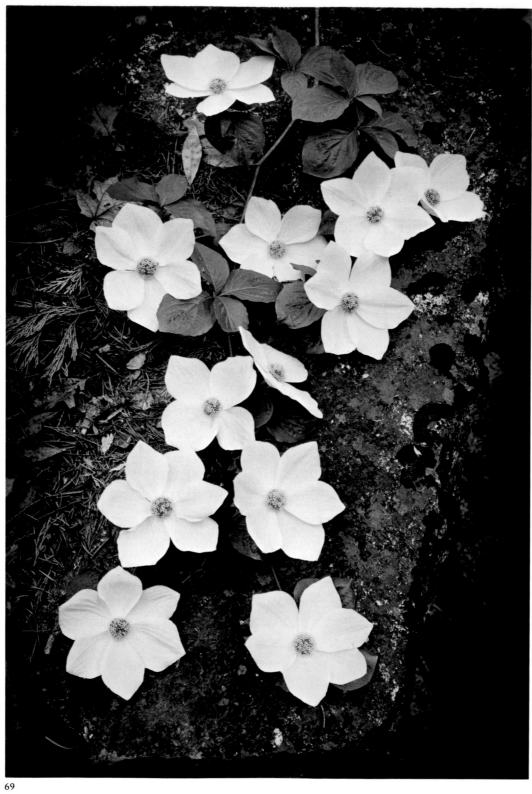

69

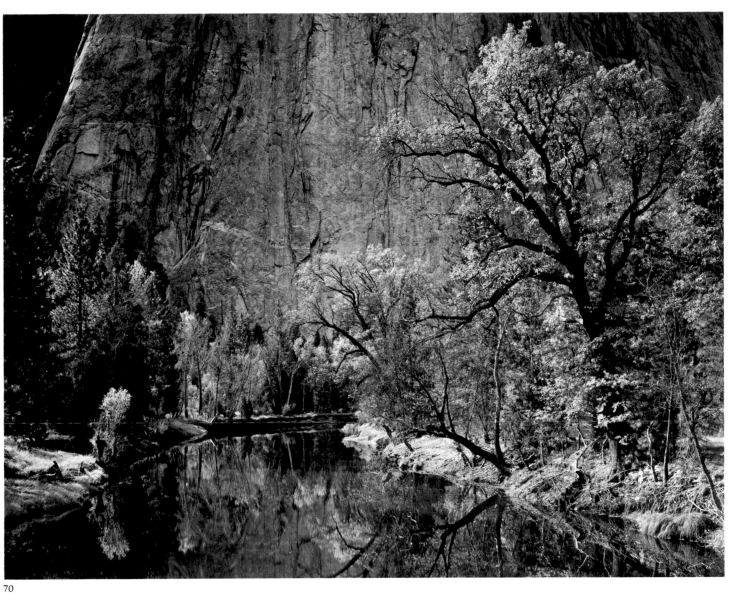

70

71 Winterstorm, Yosemite National Park 1944

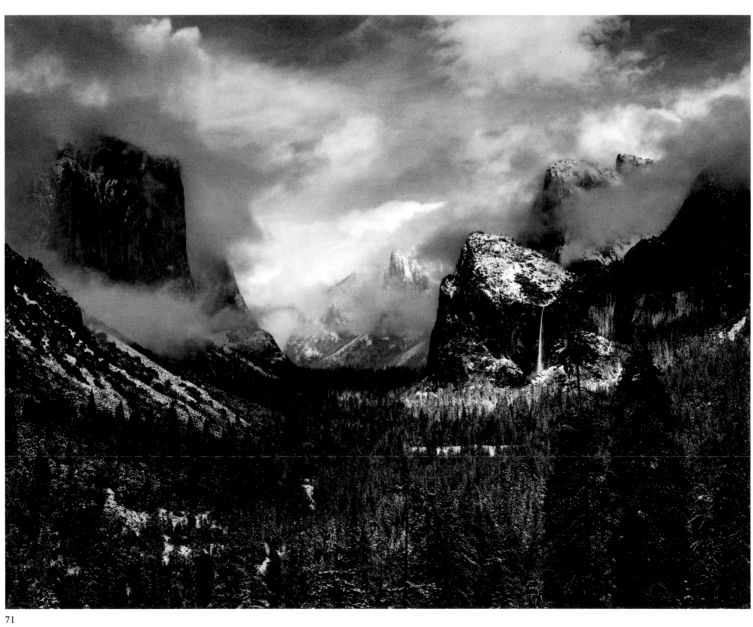

71

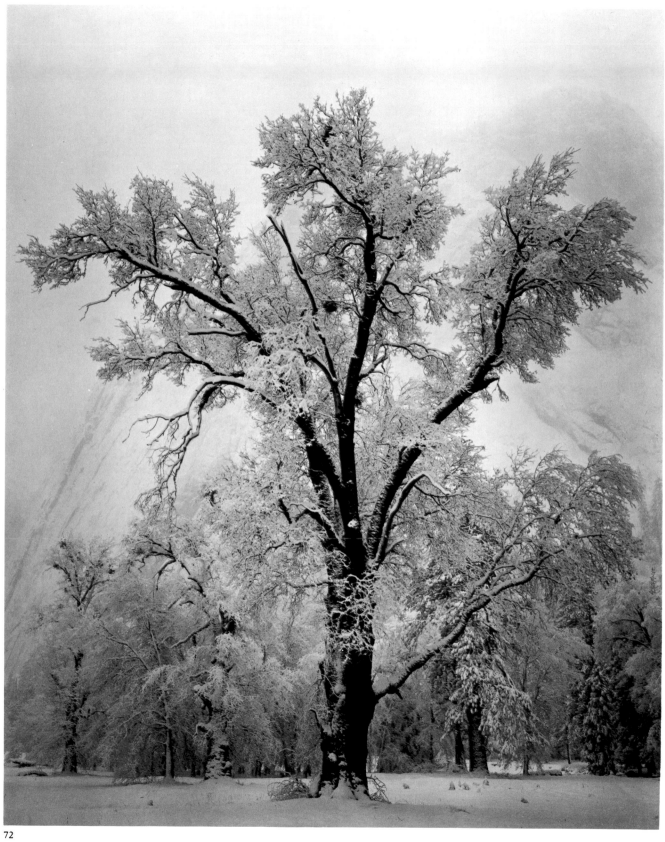

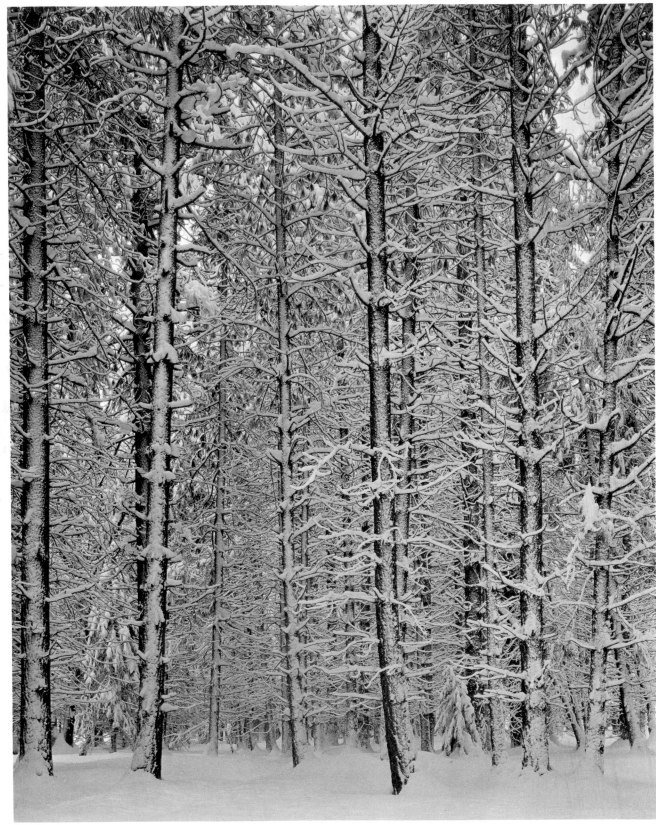

73

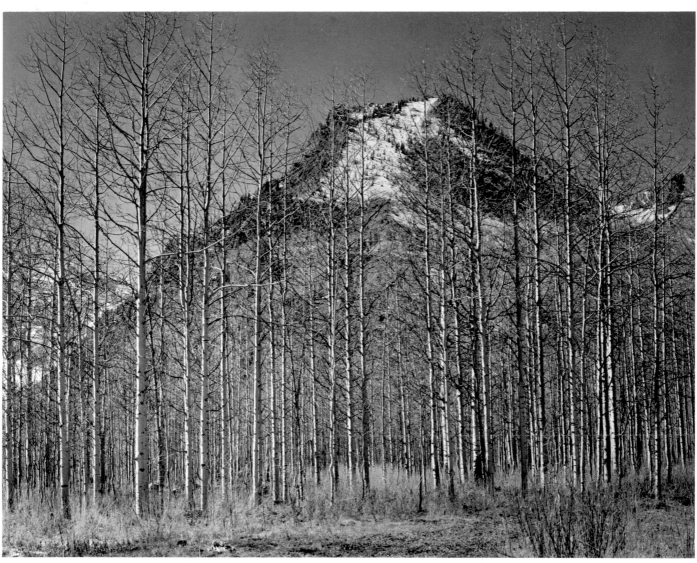

74

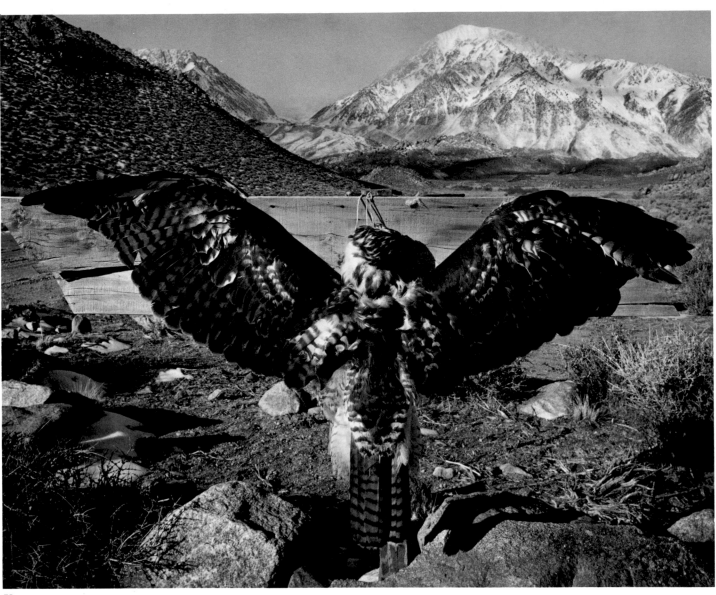

75

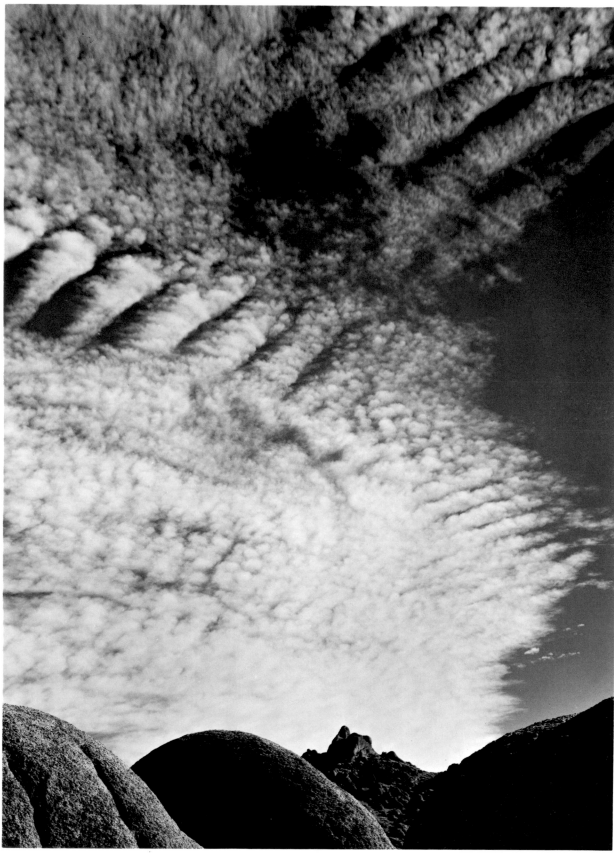

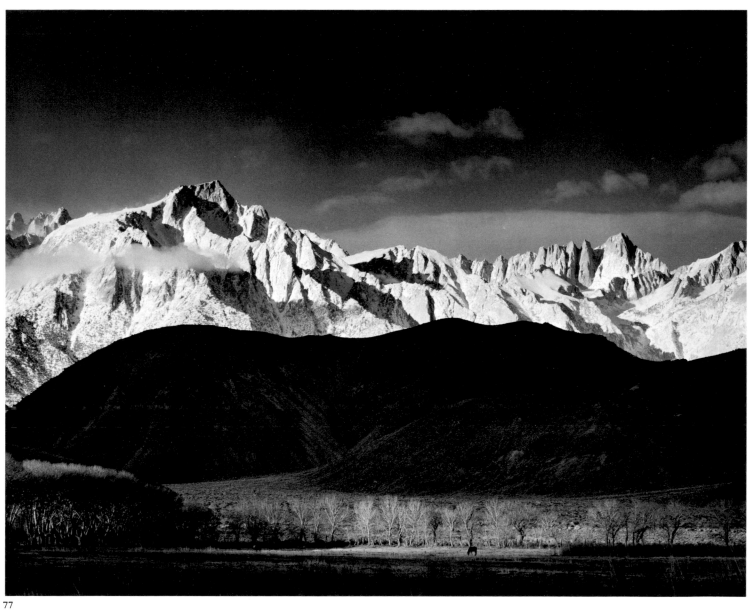

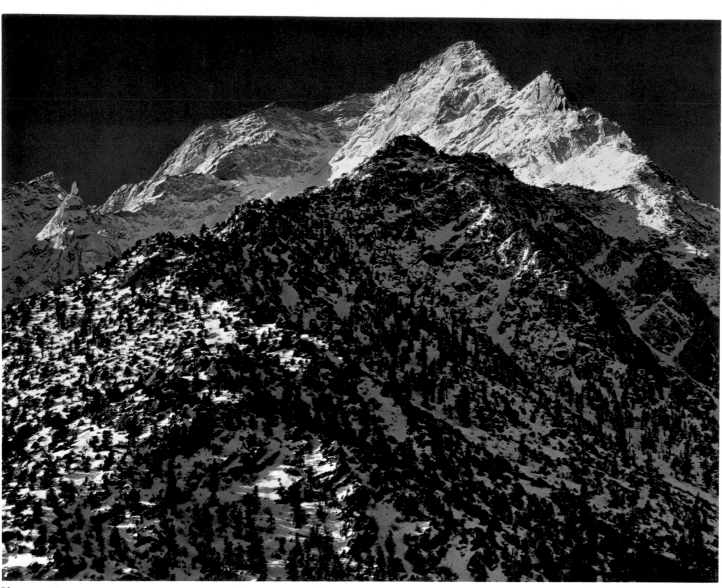

78

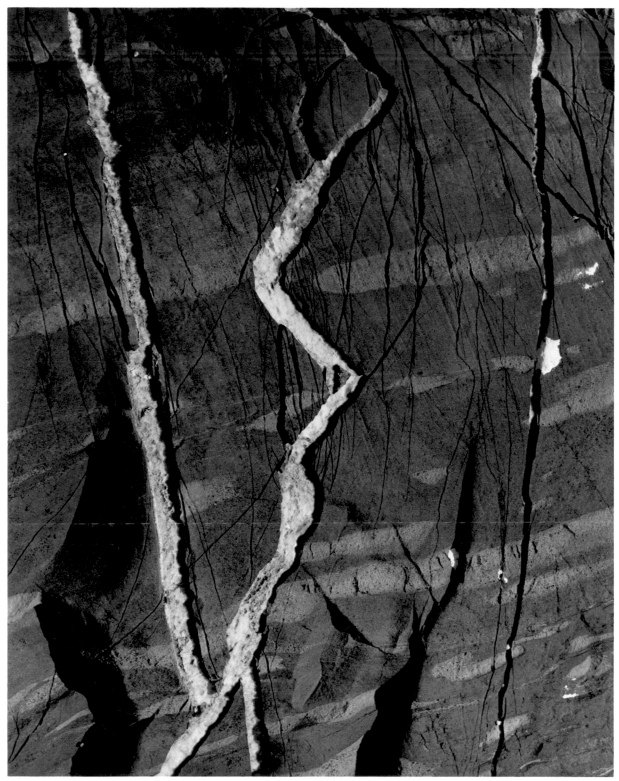

79

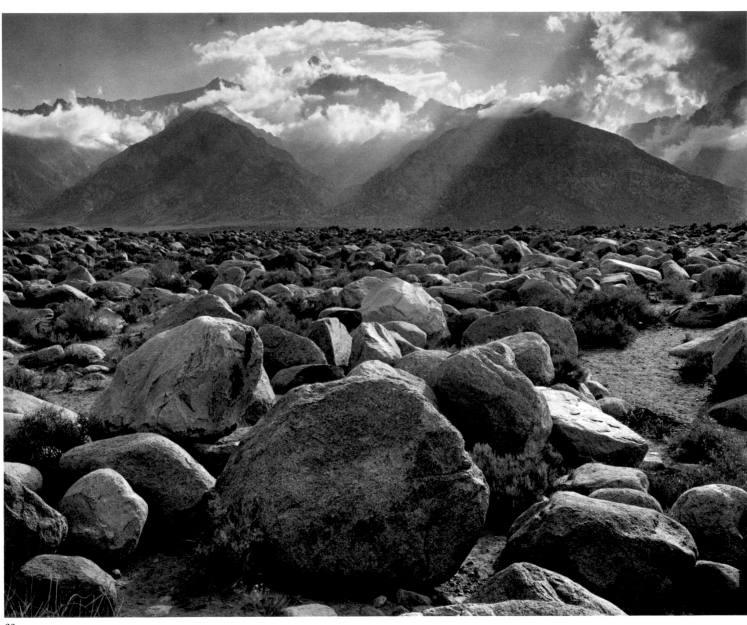

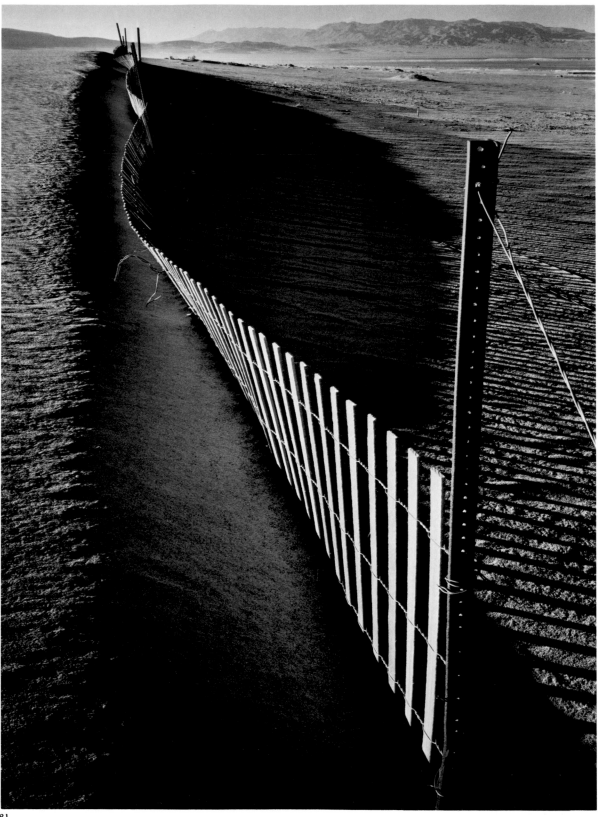

81

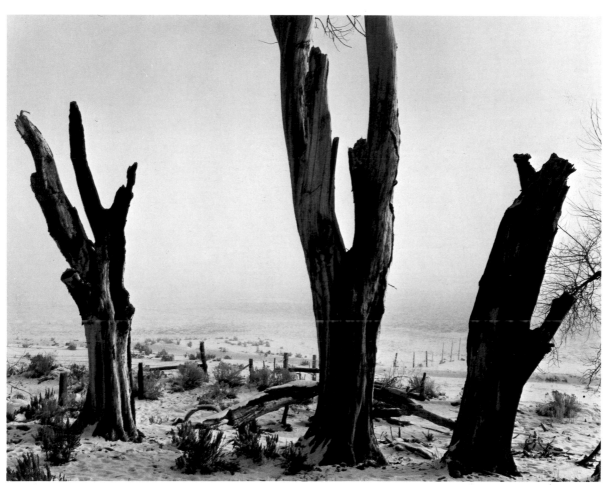

82

83 White Post, Columbia, California 1940

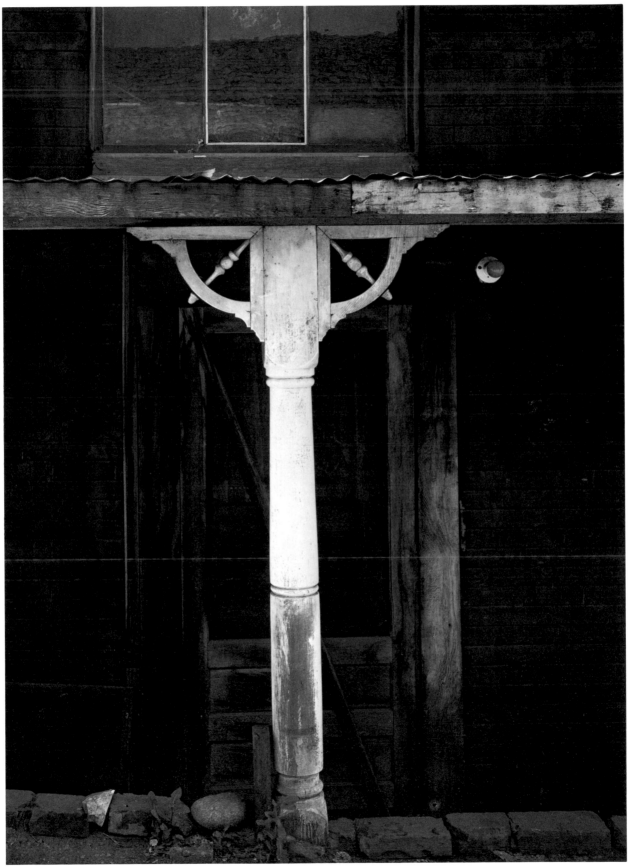

83

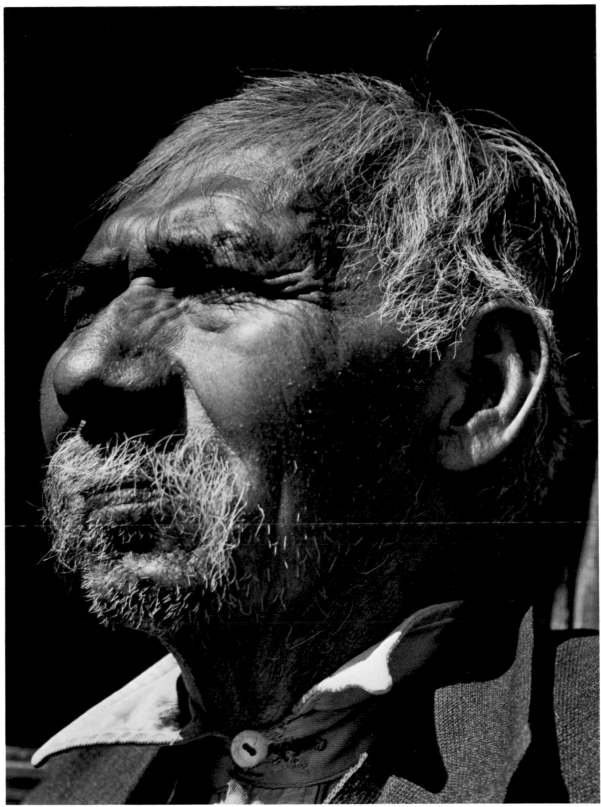

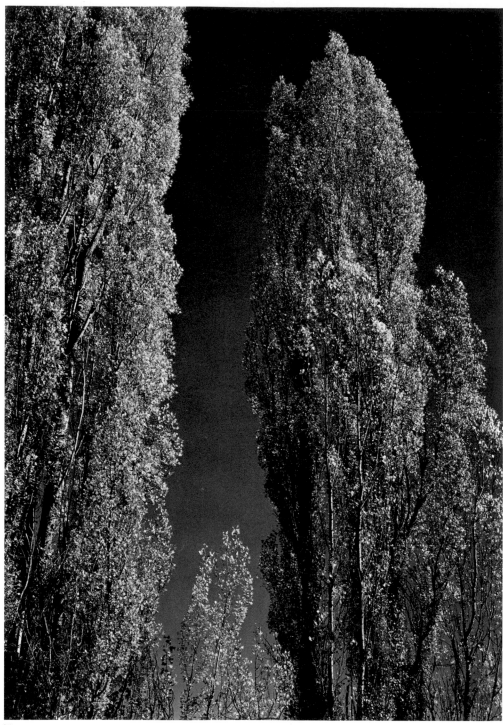

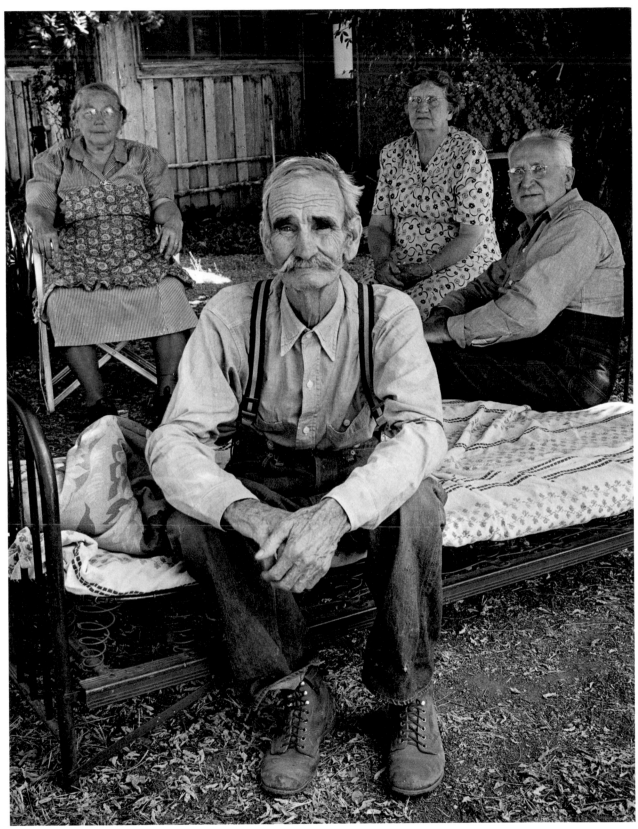

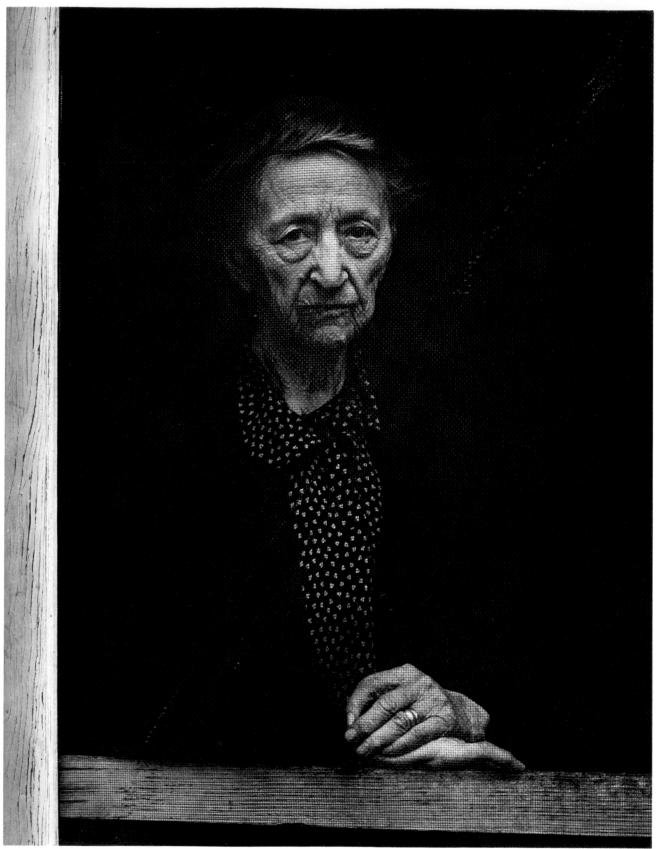

87

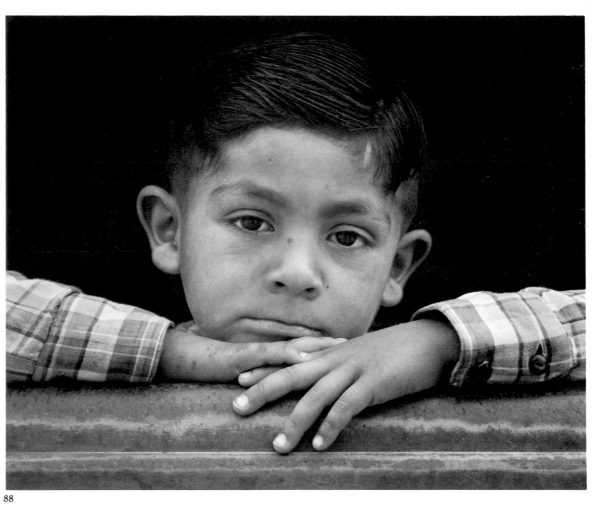

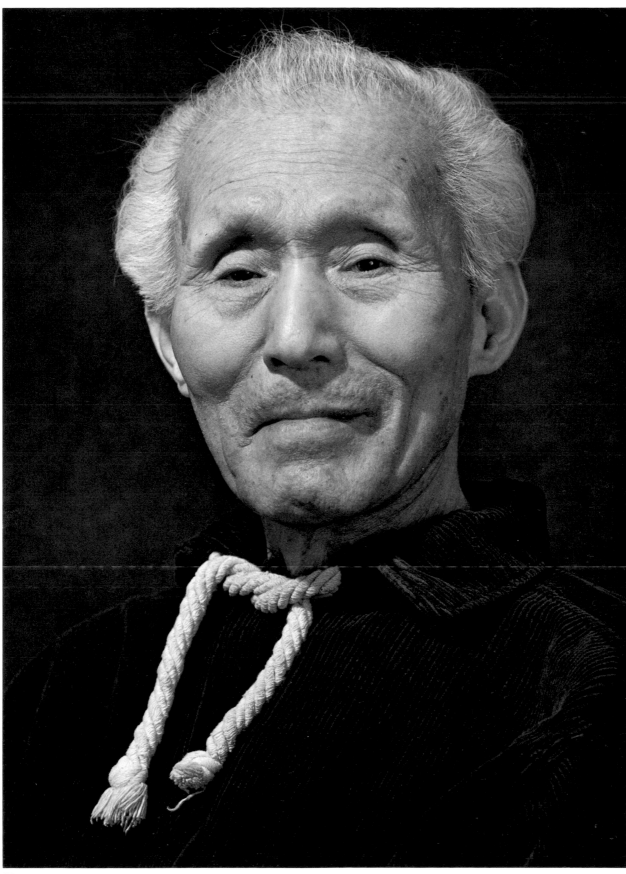

89

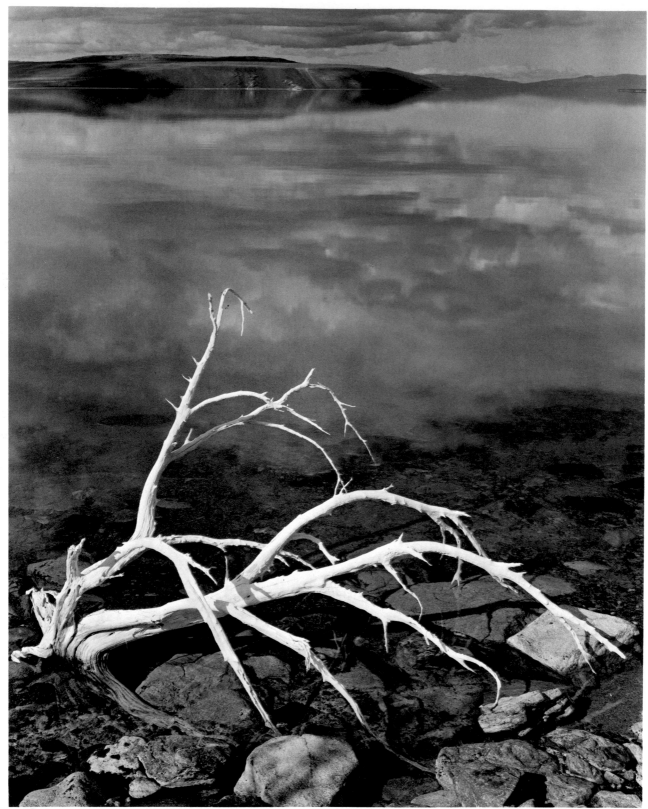

90

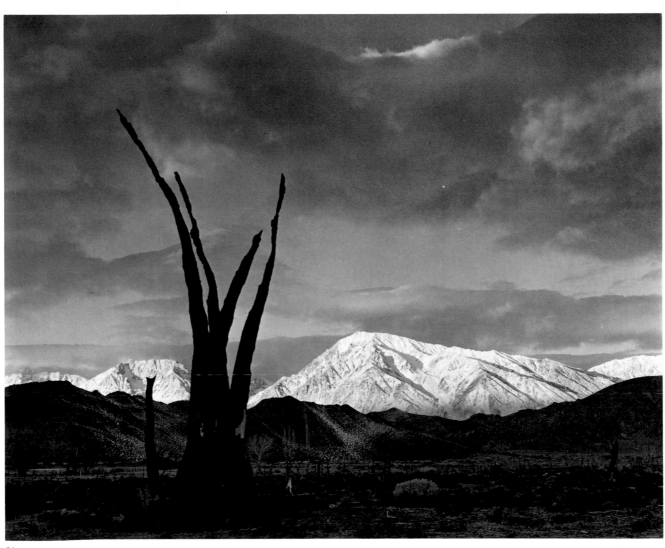

91

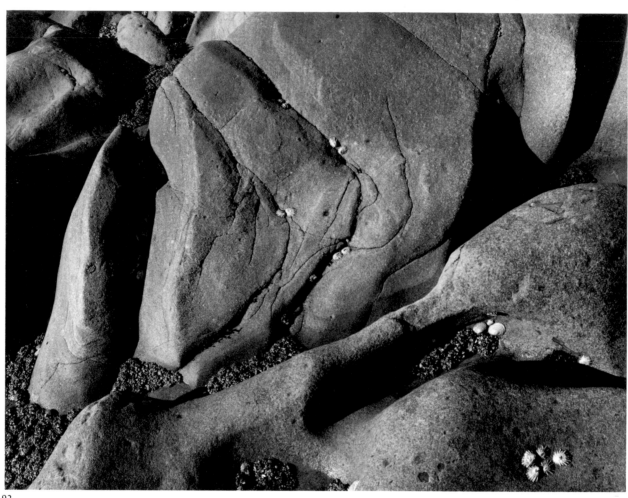

92

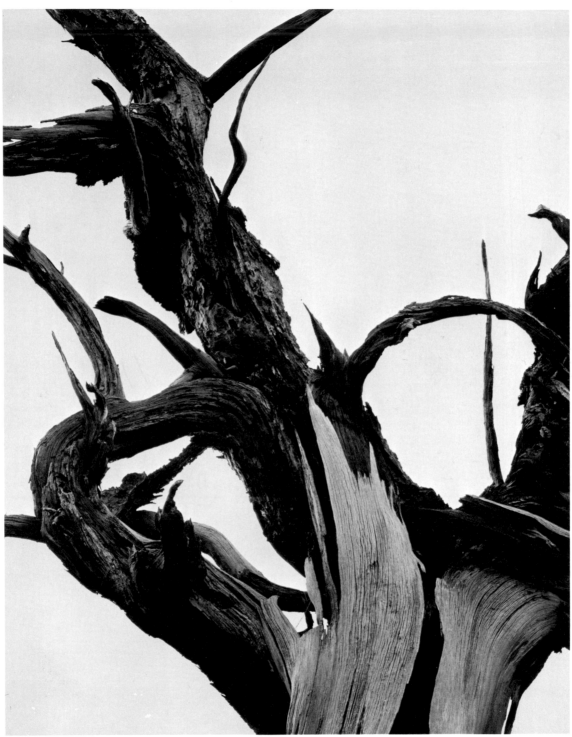

93

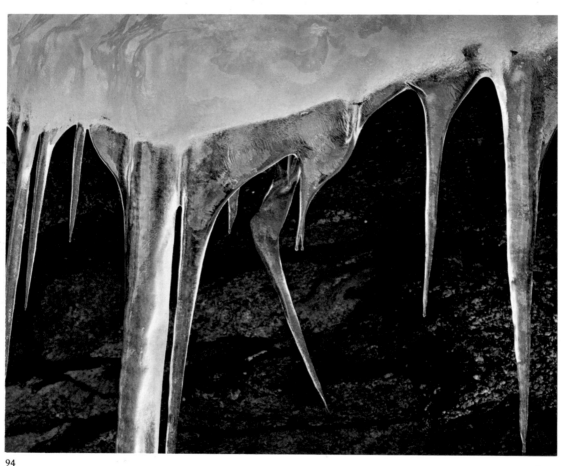
94

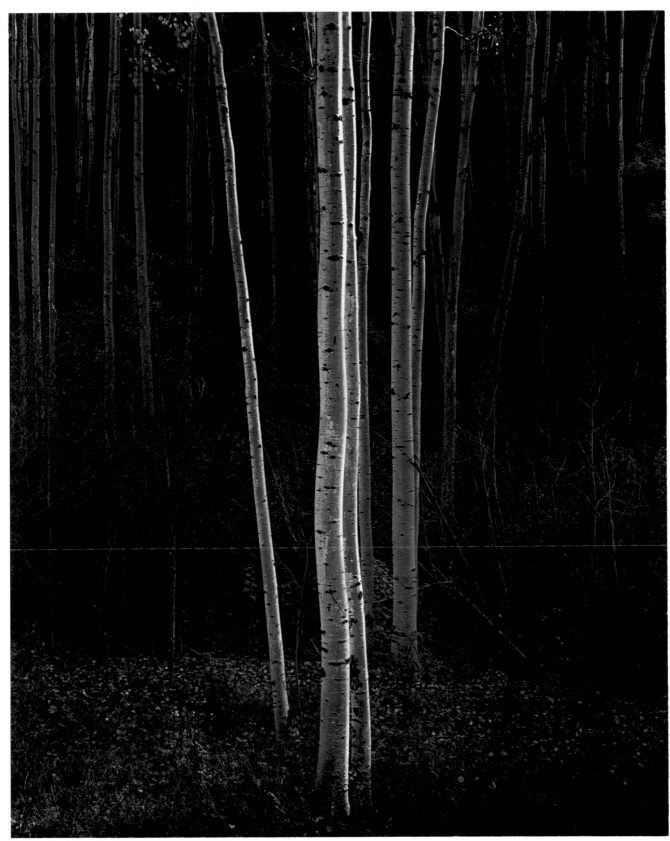

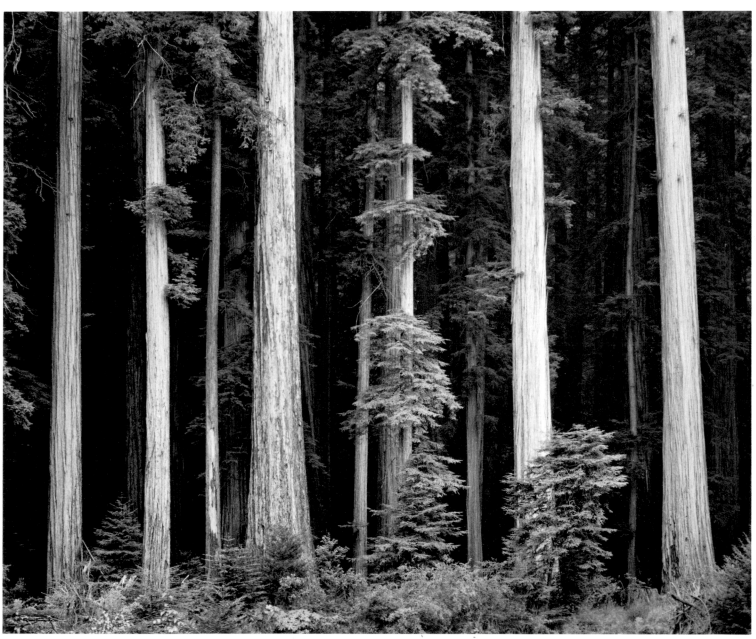

96

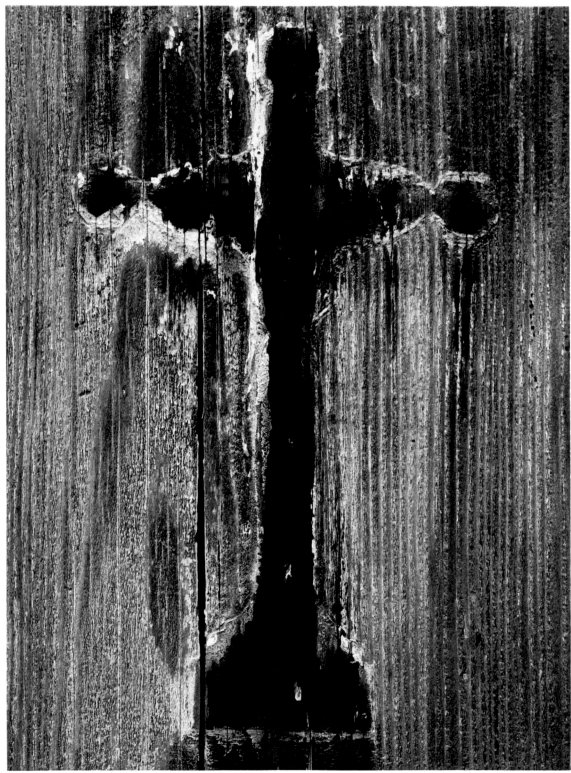

97

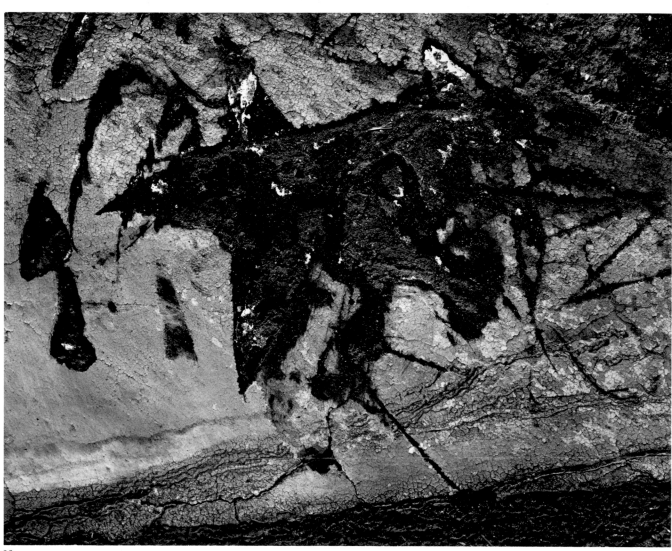

98

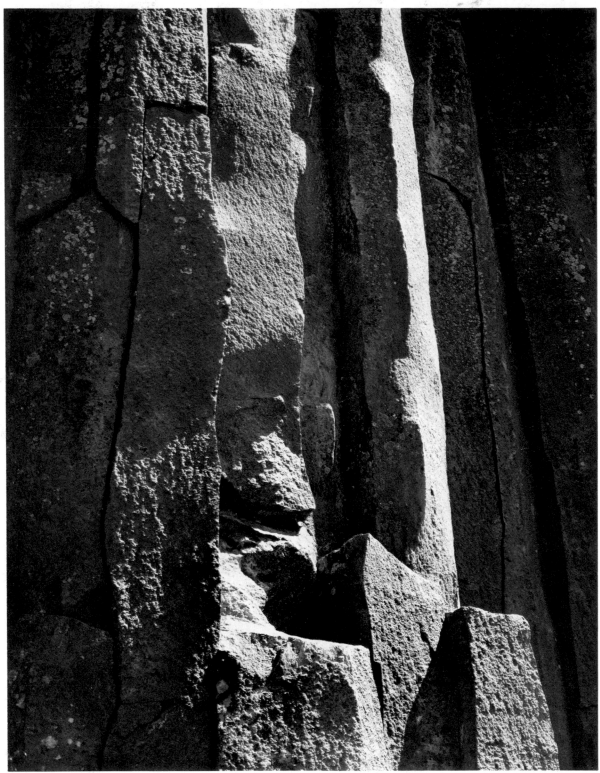

99

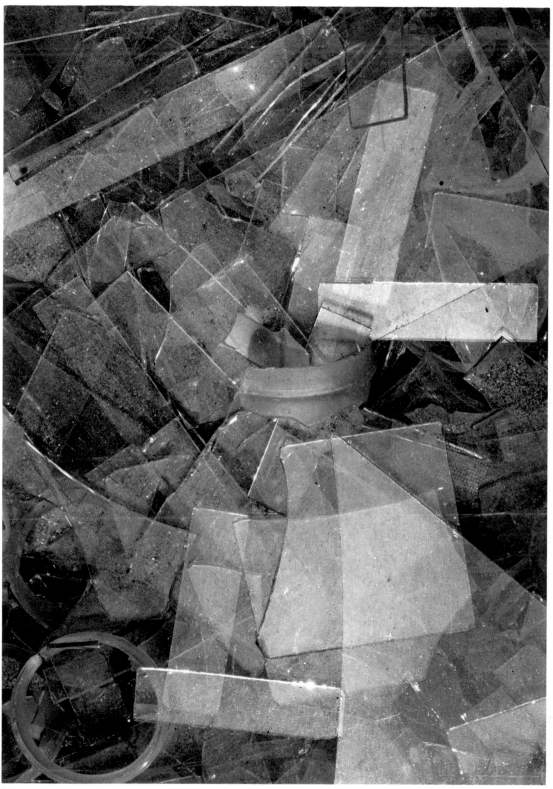

100

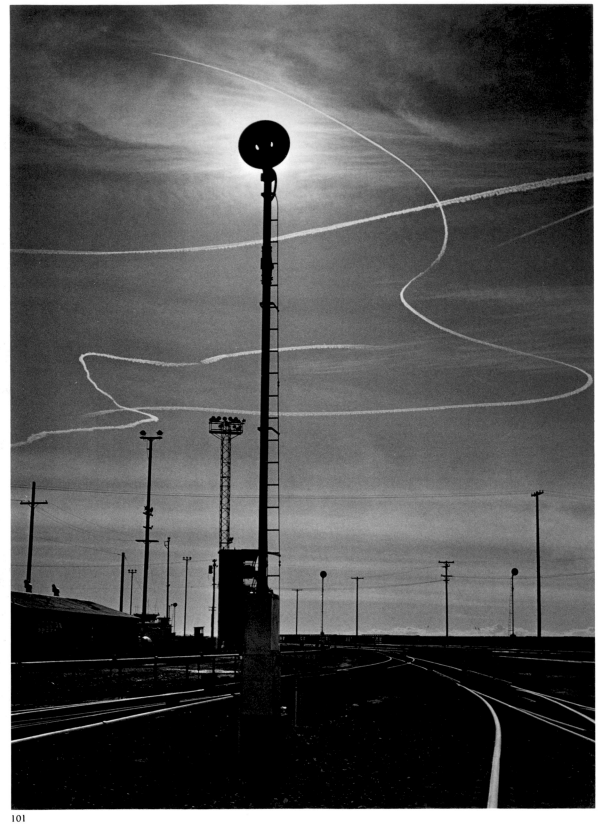

101

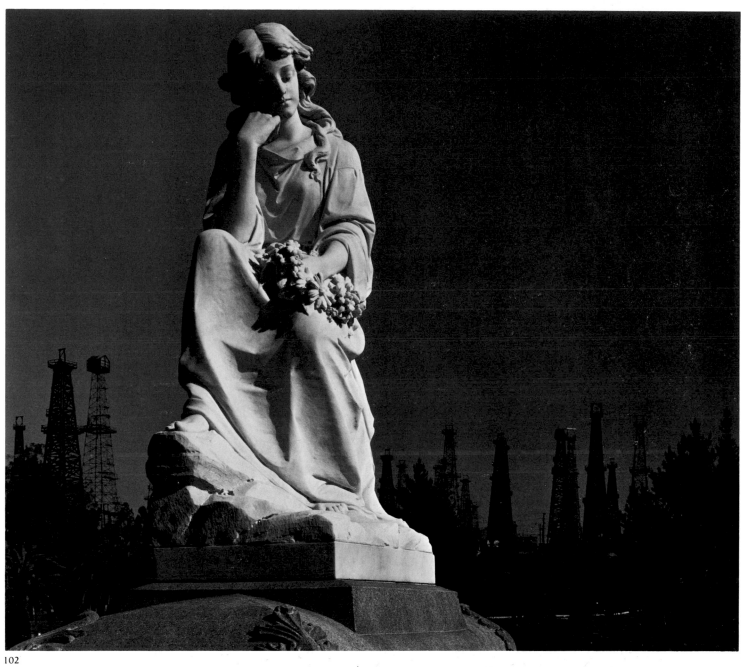

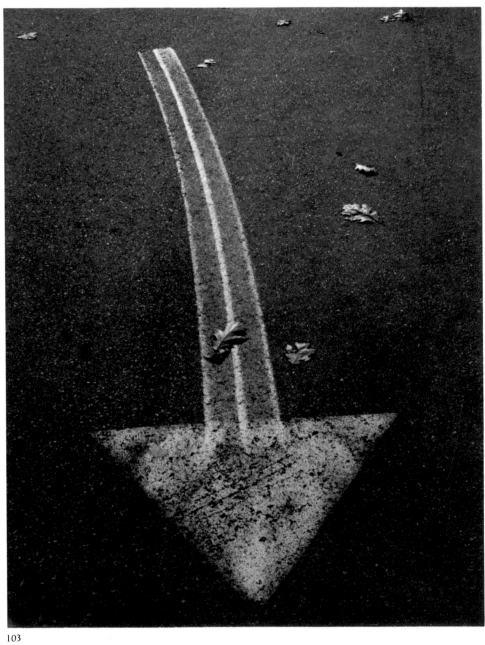

103

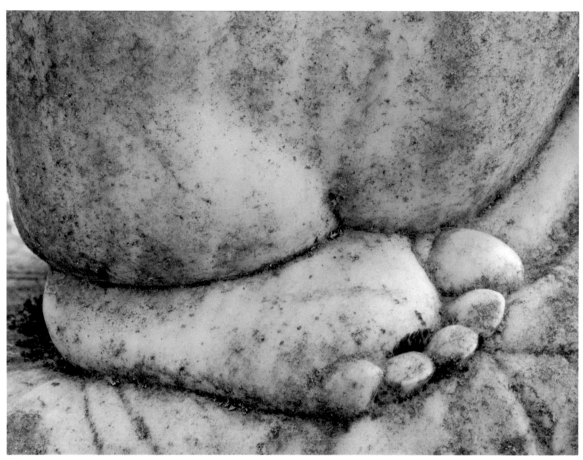

104

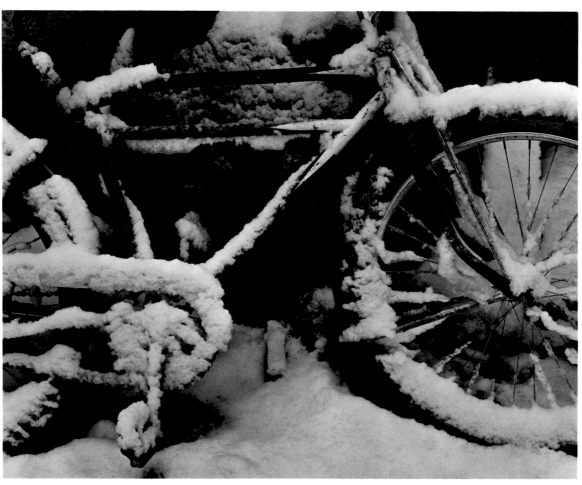

105

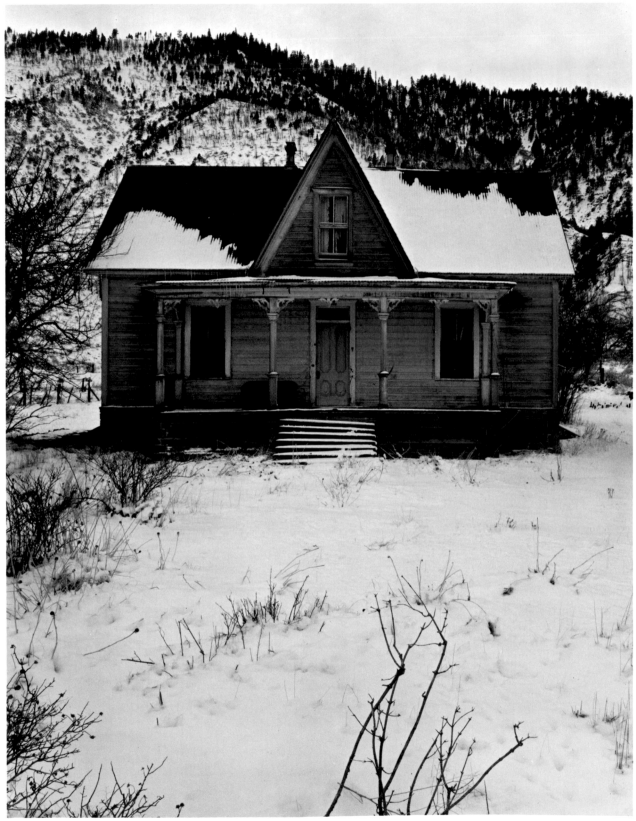

107

108

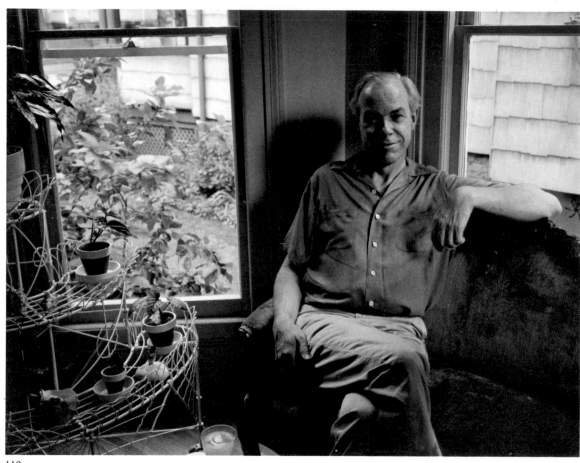

110

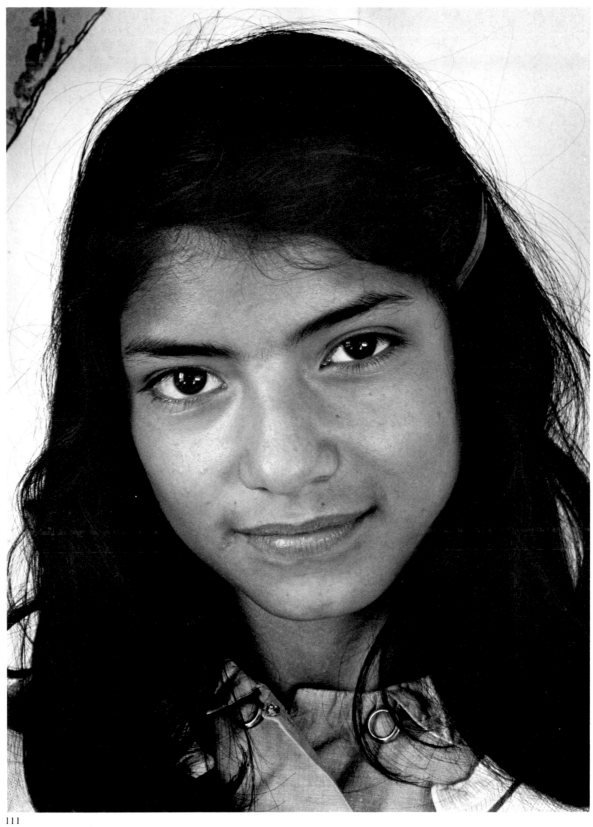

111

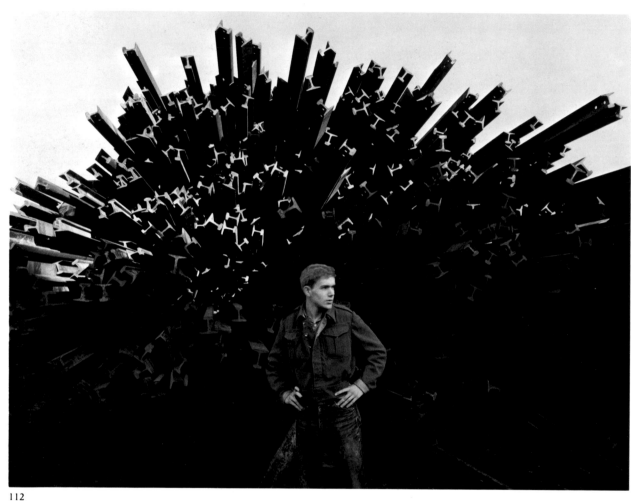

112

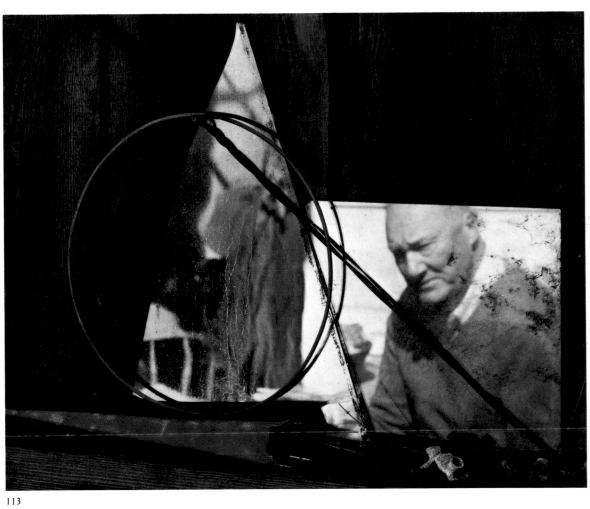

113

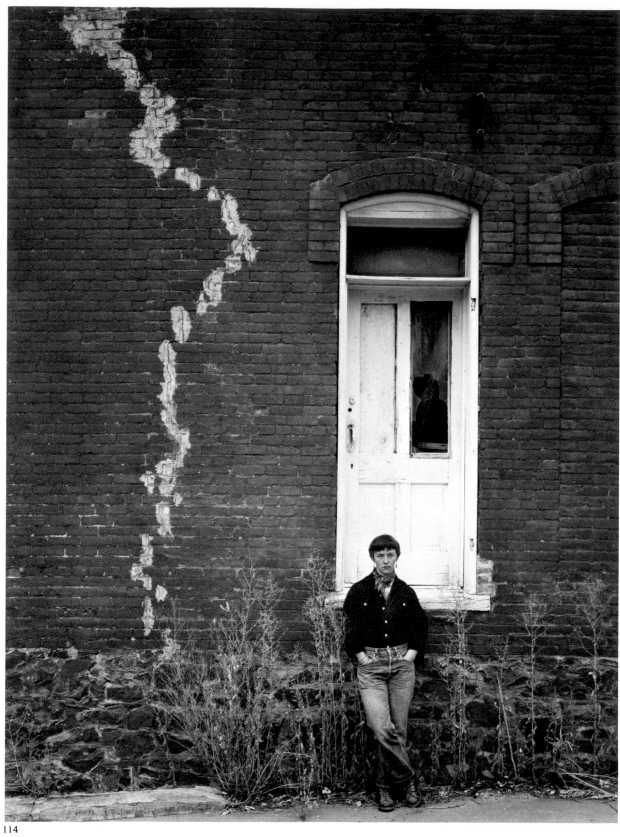

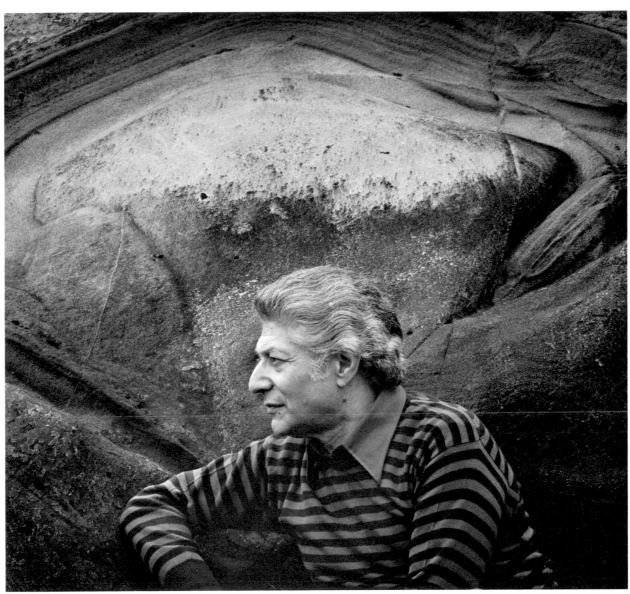

115

116 Annette Rosenshine 1968
117 Self-portrait, Monument Valley, Utah 1958

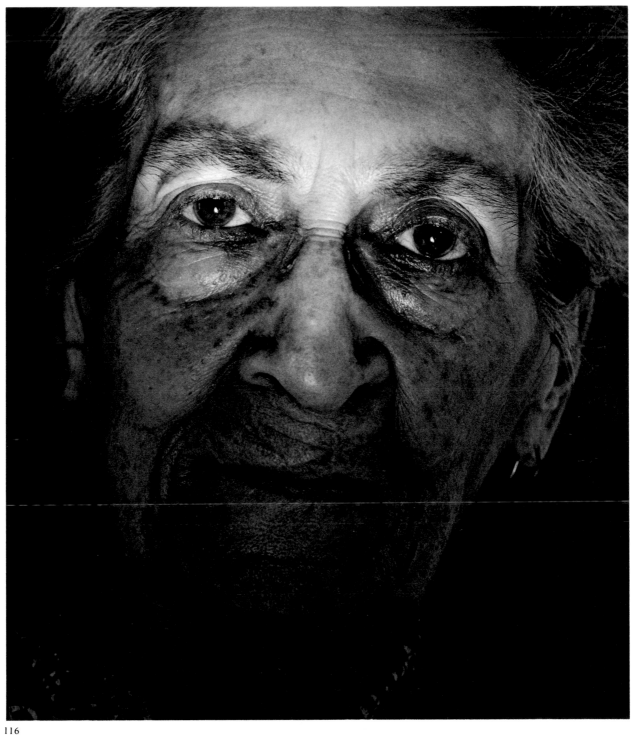

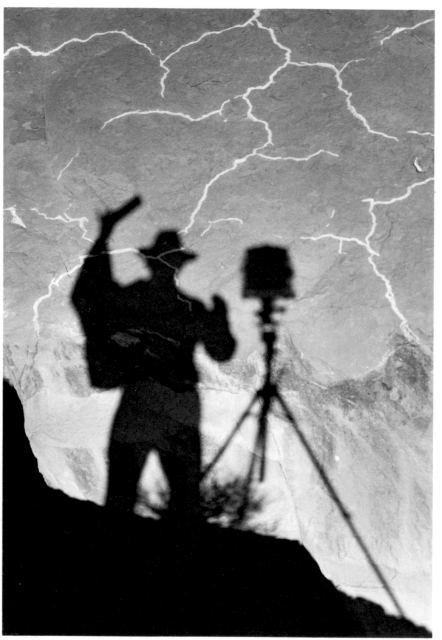

117

LIST OF PLATES

CHRONOLOGY

1902 Born, San Francisco, February 20, of New England descent. Father, Charles Hitchcock Adams; mother, Olive Bray Adams of Carson City, Nevada. His schooling erratic; mostly private instruction at home.

1914 Taught himself to play the piano and read music.

1916 To Yosemite Valley with parents. Took first photographs with a box Brownie. On return to San Francisco, studied photography with a photofinisher. Returned to Yosemite every summer, photographing, exploring. Became ardent mountaineer and conservationist.

1920 Decided on music as profession; trained as concert pianist. For four summers, served as custodian of the Le Conte Memorial, Sierra Club headquarters in Yosemite Valley.

1923 First important photography, *Banner Peak and Thousand Island Lake,* made during a clearing storm. First trip with Sierra Club into the High Sierra.

1924 and 1925 With Joseph N. LeConte and family, explored Kings River Sierra.

1927 Met Albert Bender, art patron, who proposed issuing Ansel Adams' mountain photographs in portfolio form. *Parmelian Prints of the High Sierras* launched career as photographer. To Carmel, Santa Fe, and Taos with Albert Bender. Met Robinson Jeffers, Witter Bynner, Mary Austin. Made *Monolith, the Face of Half Dome.*

1928 Married Virginia Best. To Jasper National Park as official photographer for Sierra Club.

1929 To Santa Fe and Taos working on book with Mary Austin. Met painters John Marin and Georgia O'Keeffe.

1930 To Taos; met photographer Paul Strand. Decided to become a photographer full time.

1931 Began writing column on photography for San Francisco review, the *Fortnightly.*

1932 First important one-man show, M.H. de Young Memorial Museum. With Edward Weston, Willard Van Dyke, Imogen Cunningham, Sonia Noskowiak, Henry Swift, founded Group f/64, dedicated to exhibiting and exploring the expressive potentials of straight, or "pure," photography. Inaugural show at de Young Museum became dramatic climax of international movement toward straight photography.

1933 To the East; in New York, met Alfred Stieglitz at An American Place. In San Francisco, started Ansel Adams' Gallery, devoted to photography and other arts. Taught and lectured. Son, Michael, born.

1934 First series of technical articles in *Camera Craft.* January–May. In January, gave up his gallery; returned to "simple photographic life." Elected to Board of Directors of Sierra Club (continuously reelected until resignation in 1971).

1935 Started work with photo-murals, and also with the miniature camera. Daughter, Anne, born.

1936 To New York and Washington, as repre-

sentative of Sierra Club. One-man show at An American Place; first young photographer shown by Stieglitz since Paul Strand in 1917.

1937 Moved to Yosemite Valley, where his wife, Virginia, had inherited Best's Studio concession. With Edward Weston to High Sierra; with David McAlpin and Georgia O'Keeffe, through the Southwest.

1938 With Edward Weston to Owens Valley; with O'Keeffe and McAlpin to High Sierra.

1939 To New York; met Beaumont and Nancy Newhall.

1940 Conducted *U.S. Camera* Photographic Forum, with Edward Weston, in Yosemite. Helped Beaumont Newhall and David McAlpin found first department of photography as a fine art, at Museum of Modern Art, New York.

1941 Appointed photo-muralists to Department of the Interior; series of landscapes and lyric closeups in National Parks. Taught at Art Center School, Los Angeles; developed famous Zone System of exposure control.

1942 Photo-mural project lapsed during World War II. Taught, served as consultant to Armed Services. Worked with Dorothea Lange for Office of War Information.

1943 Began photo-essay on plight of loyal Japanese-Americans; photographed at Manzanar Relocation Center, Owens Valley, California.

1944 To New York. Lecture series at Museum of Modern Art. Book, *Born Free and Equal,* and exhibition, *Manzanar,* at Museum of Modern Art.

1945 Gave course on photography, Museum of Modern Art.

1946 Founded first department of photography at California School of Fine Arts, San Francisco. Received Guggenheim Fellowship enabling him to photograph National Parks and Monuments. Fellowship renewed, 1948.

1947 Journeys to National Parks, Alaska, Hawaii.

1948 through 1950 To Alaska; to Maine and several other trips east.

1949 Appointed consultant to Polaroid Corporation.

1953 To Utah, collaborating with Dorothea Lange on photo-essay about Mormons for *Life.*

1955 Began holding workshops in Yosemite each June.

1957 To Hawaii.

1958 Received Brehm Memorial Award for distinguished contributions to photography, at Rochester Institute of Technology. Received third Guggenheim Fellowship for creative work.

1959 *Photography: The Incisive Art,* series of five TV films in which Adams served as protagonist.

1961 Received Doctor of Fine Arts degree, University of California.

1962 Moved to Carmel, California.

1963 Received John Muir Award for services to conservation. Retrospective show, 1923–1963, M.H. de Young Museum, San Francisco.

1966 Elected Fellow, American Academy of Arts and Sciences.

1967 Received Doctor of Humanities degree, Occidental College. Co-founder and President, Friends of Photography, Carmel.

1968 Received Conservation Service Award, Department of the Interior.

1969 Received Progress Medal, Photographic Society of America. Delivered Alfred Stieglitz Memorial Lecture at Princeton University.

1970 Recipient of the Chubb Fellowship, Yale University.

1971 Received American Institute of Architects' Special Citation.

1972 Retrospective show, *Recollected Moments,* San Francisco Museum of Modern Art, subsequently circulated by U.S.I.S. in South America and Europe.

1974 Retrospective show, Metropolitan Museum of Art, New York, subsequently circulated in the U.S. by the Museum and in Europe and Russia by U.S.I.S. Received Doctor of Fine Arts degree, University of Massachusetts at Amherst. First trip to Europe, to attend workshop in Arles, France.

1975 Delivered Horace M. Albright Conservation Lecture at University of California at Berkeley. Received Fellowship in Society of Photographic Scientists and Engineers. Received Doctor of Fine Arts degree from University of Arizona at Tucson.

1976 Met with President Gerald R. Ford at the White House to discuss National Park policy. Received Russell House University Union Award for distinction in the arts from University of South Carolina. Traveled to Scotland, England, Switzerland, and France to photograph and lecture. Received Honorary Fellowship from Royal Photographic Society of Great Britain.

1977 Received Doctor of Humane Letters Award from Art Center College of Design, Los Angeles. Received Trustees Gold Medal from National Cowboy Hall of Fame, Oklahoma City, for outstanding contribution to photography.

1978 Elected Honorary Vice President of the Sierra Club. Received resolution from the California Legislature commending Ansel Adams' contribution to photography. Elected honorary member of the Photographers' Section of the Moscow Committee of Graphic Artists.

1979 Retrospective show, *Ansel Adams and the West,* The Museum of Modern Art, New York, subsequently circulated in the U.S. by the Museum.

SELECTED BIBLIOGRAPHY

Books:

Taos Pueblo Photographed by Ansel Adams and described by Mary Austin. 12 original prints. San Francisco, 1930.

Sierra Nevada: The John Muir Trail Introduction and 50 facsimile halftones of photographs by Ansel Adams. Berkeley: Archtype Press, 1938

Illustrated Guide to Yosemite Valley (with Virginia Adams). San Francisco: H. S. Crocker Co., 1940. 8th revised edition, San Francisco: Sierra Club, 1963

A Pageant of Photography Catalogue of exhibition directed by Adams for Department of Fine Arts, Golden Gate Exposition. Articles by Grace McCann Morley, Dorothea Lange, Beaumont Newhall, and others. San Francisco: San Francisco Bay Exposition Co., 1940

Michael and Anne in the Yosemite Valley Text by Virginia Adams. New York and London: Studio Publications, 1941

Born Free and Equal: The Story of Loyal Japanese-Americans at Manzanar Relocation Center. New York: U.S. Camera. 1944

Muir, John, *Yosemite and the High Sierra* Edited from his books, articles and journals by Charlotte Mauk. Introduction and 64 photographs by Ansel Adams. Boston: Houghton Mifflin, 1948

Austin Mary, *The Land of Little Rain* New edition with introduction by Carl Van Doren, notes and 48 photographs by Ansel Adams. Boston: Houghton Mifflin, 1950

My Camera in Yosemite Valley Text and photographs by Ansel Adams. Yosemite National Park: Virginia Adams. Boston: Houghton Mifflin, 1949

My Camera in the National Parks Text and photographs by Ansel Adams. Yosemite National Park: Virginia Adams. Boston: Houghton Mifflin, 1950

Death Valley Text by Nancy Newhall. Boston: New York Graphic Society. Originally published by 5 Associates, San Francisco, 1954, 3rd edition, 1963

Mission San Xavier del Bac Text by Nancy Newhall. San Francisco: 5 Associates, 1954

The Pageant of History in Northern California Text by Nancy Newhall. San Francisco: American Trust Co. (Wells Fargo), 1954

The Islands of Hawaii Text by Edward Joesting. Honolulu: Bishop National Bank (First National Bank of Hawaii), 1958

Yosemite Valley Edited by Nancy Newhall. San Francisco: 5 Associates, 1959

This is the American Earth Text by Nancy Newhall. Photographs by Ansel Adams, Edward Weston, Brett Weston, Cedric Wright, Werner Bischoff, Henri Cartier-Bresson, Wynn Bullock, Dick McGraw, Philip Hyde, William Garnett, Margaret Bourke-White, Pirkle Jones, Gerry Sharpe, others. San Francisco: Sierra Club, 1960

Corle, Edwin, *Death Valley and the Creek Called Furnace* Photographs by Ansel Adams. Los Angeles: Ward Ritchie Press, 1962

Introduction to Hawaii Text by Edward Joesting. Redwood City: 5 Associates, 1964

Fiat Lux: The University of California Text by Nancy Newhall. New York: McGraw Hill, 1967

The Tetons and the Yellowstone Text by Nancy Newhall. Redwood City: 5 Associates, 1970. Now published by New York Graphic Society, Boston.

Ansel Adams Edited by Liliane De Cock, Foreword by Minor White. Hastings-on-Hudson, New York: Morgan and Morgan, 1972. Now published by New York Graphic Society, Boston.

Singular Images: A Collection of Polaroid Land Photographs Text by Edwin Land, David H. McAlpin, Jon Holmes, and Ansel Adams. Hastings-on-Hudson, New York: Morgan and Morgan, 1974. Now published by New York Graphic Society, Boston.

Ansel Adams: Images 1923–1974 Foreword by Wallace Stegner. Published in a regular edition and in a limited, deluxe edition of 1,000 copies, signed and numbered, in a boxed portfolio, with a signed and numbered original print. Boston: New York Graphic Society, 1974

Photographs of the Southwest Photographs and text by Ansel Adams. Essay by Lawrence Clark Powell. Boston: New York Graphic Society, 1976

The Portfolios of Ansel Adams Introduction by John Szarkowski. Boston: New York Graphic Society, 1977. Facsimile edition of *Taos Pueblo* (1930) Limited to 950 signed and numbered copies. Boston: New York Graphic Society, 1977

Yosemite and the Range of Light Photographs and text by Ansel Adams. Introduction by Paul Brooks. Published in a regular edition and in a limited, deluxe edition of 250 copies, signed and numbered, in a presentation box, accompanied by a signed and numbered original print (five different prints, 50 of each). Boston: New York Graphic Society, 1979

Technical Manuals:

Making A Photograph Text and photographs by Ansel Adams. London and New York: The Studio, 1935. 2nd edition, 1938; 3rd edition, 1948

Basic Photo Series. Text and photographs by Ansel Adams. Hastings-on-Hudson, New York: Morgan and Morgan. Now published by New York Graphic Society, Boston. 1. *Camera and Lens,* 1948; enlarged and revised edition, 1970; 2. *The Negative,* 1948; 3. *The Print,* 1950; 4. *Natural*

Light Photography, 1952; 5. *Artificial Light Photography,* 1956
Polaroid Land Photography Manual Text and photographs by Ansel Adams, with a portfolio of work by other photographers. Hastings-on-Hudson, New York: Morgan and Morgan, 1963.
Polaroid Land Photography Revised and expanded edition. Text (with the collaboration of Robert Baker) and photographs by Ansel Adams, with 2 portfolios of work by other photographers. Boston: New York Graphic Society, 1978
The Ansel Adams Photography Series A complete revision of the *Basic Photo Series,* to begin in 1980. Boston: New York Graphic Society

Articles by Adams:

ON CONSERVATION
Sierra Club Bulletin: "Ski-Experience," 1931; "Retrospect: 1931," 1932; "Problems of Interpretation of the Natural Scene," 1945
"Yosemite—1938: Compromise in Action," *National Parks Magazine,* October/December, 1958
"The Artist and the Ideals of Wilderness," in D. Brower, ed., *Wilderness: America's Living Heritage.* San Francisco: Sierra Club, 1961

ON PHOTOGRAPHY:
"The New Photography," *Modern Photography 1934-35,* London and New York: Studio Publications, 1934
"The Expanding Photographic Universe," *Miniature Camera Work,* New York, Morgan and Lester, 1938
"Personal Credo—1943," *American Annual of Photography, 1944*
"Danger Signals," *PSA Journal,* November 1948
"The Profession of Photography," *Aperture,* No. 3, 1952
"Color Photography as a Creative Medium" *Image,* November 1957
"Some Definitions," Brehm Memorial Award lecture, *Image,* March 1957
"Contemporary American Photography," *Universal Photo Almanac, 1951*
"Natural Light," *Photography Annual 1957,* New York: Ziff-Davis, 1956
"Pictures that Speak," *Infinity,* February 1960
"A Time for Affirmation," *Infinity,* November 1960
"The Communicative Camera," *Camera 35,* October/November 1960
"Balance between Science and Creativity in Photography," Lecture at Photography in Science Conference, University of California, *The Rangefinder,* December 1962
ARTICLES ON OTHER PHOTOGRAPHERS:
"Pirkle Jones, Photographer," *U.S. Camera Magazine,* October 1952
"The Photography of Joseph N. Le Conte," *Sierra Club Bulletin,* 1944
"The Jacob A. Riis Exhibit," *Photo Notes,* November 1947
"Vittorio Sella: His Photographs," *Sierra Club Bulletin,* 1946
"Letters to Dorothy Norman Received Shortly After Stieglitz' Death," *Stieglitz Memorial Portfolio,* New York: Twice-A-Year Press, 1947
Review of *Mexican Photographys* by Paul Strand, *U.S. Camera,* December 1940
Appreciation of Yosemite Photographs by R. H. Vance, *A Camera in the Gold Rush,* San Francisco: Book Club of California, 1946
Review of Edward Weston exhibition, *Fortnightly* (San Francisco), December 18, 1931
Review of *The Art of Edward Weston,* ed. and publ. by Merle Armitage, *Creative Art,* May 1933
Review of *The Daybooks of Edward Weston* in *Contemporary Photographer,* Winter, 1962
"Photography and Cedric Wright," *Sierra Club Bulletin,* 1941
Foreword to *Words of the Earth* by Cedric Wright, San Francisco: Sierra Club, 1960

ON PHOTOGRAPHIC TECHNIQUE:
Camera Craft: "An Exposition of My Photographic Technique," January-April, 1934
Zeiss Magazine: (series of articles, 1937-1938)
U.S. Camera: (series of articles, 1940-1941)
"A Design for Printing," *Graphic Graflex Photography,* ed. by W. D. Morgan & H. Lester, New York: Morgan & Lester, 1940
"How I Use the Polaroid Camera," *Modern Photography,* September 1951
"Enlarging Papers and Printing," *The New Leica Manual,* 12th ed., New York: Morgan & Lester, 1951
"Single Lens Reflex; Get What You See," *American Photography,* August 1952
U.S. Camera Annual, 1949: "The National Parks."—1954: "Nine Photographs." —1960: "The Islands of Hawaii" (text by Edward Joesting). —1963: "The Story of a Winery" (with Pirkle Jones; text by Elsa Gidlow).
Complete Photographer, New York National Educational Alliance 1941-1943: "Architectural Photography," "Geometrical Approach to Composition," "Mountain Photography," "Printing."

Photographic Essays:

Fortune, June, 1947: De Voto, Bernard, "The National Parks"

Coronet, January, 1949: Muir, John, quotations from: "The Incomparable Valley—Yosemite"
Life, September 18, 1950: "Mockingbird Flower"
Arizona Highways: Text by Nancy Newhall. "Canyon de Chelle," June 1952; "Sunset Crater," July 1952; "Tumacacori," Nov 1952; "Death Valley," October 1953; "Organ Pipe National Monument," January 1954; "Mission San Xavier del Bac," April 1954
U.S. Camera Annual: "The National Parks," 1949; Joesting, Edward, "The Islands of Hawaii," 1960; Gidlow, Elsa, "The Story of a Winery," 1963; *Time,* July 23, 1956: "The National Parks: The U.S.'s Time Dimension"
Natural History, May 1960: Joesting, Edward, "The First Hawaiians: Polynesian Pioneers"
Art in America, No. 2, 1961: Newhall, Beaumont, "A Day with John Marin"
American Heritage. April 1962: Newhall, Nancy, "Sanctuary in Adobe"
Horizon, March 1960: Brooks, Paul, "Man's Way with the Wilderness"
Réalités, June 1962: Butor, Michel, "L'Appel des Rocheuses"
Discovery, Summer 1962: Carhart, Arthur, "Going to the Sun on U.S. 89"

About Ansel Adams

BIOGRAPHY:

Newhall, Nancy, *Ansel Adams,* Volume I: *The Eloquent Light,* San Francisco: Sierra Club, 1963. Volume II: *The Enduring Moment* (in preparation)

ARTICLES:

LeConte, Joseph N., Review of *Parmelian Prints of the High Sierras, Sierra Club Bulletin,* 1928
Farquahar, Francis P., "Ansel Adams," *Touring Topics,* February 1931
Review of *Sierra Nevada: The John Muir Trail, Sierra Club Bulletin,* June 1939
Newhall, Beaumont, Review of "The New Photography," *American Magazine of Art,* January 1935
Review of *Making a Photograph, ibid.,* August 1935
"How Ansel Adams Makes an Exposure," *Popular Photography,* Feb 1963
and Nancy Newhall, "Ansel Adams," *Masters of Photography,* New York: George Braziller, 1958
Kennedy, Clarence, "Photographs in Portfolio," *Magazine of Art,* February 1950
Newhall, Nancy, Review of *My Camera in Yosemite,* by Ansel Adams, *Magazine of Art,* December 1950
Page, Christina, "The Man from Yosemite: Ansel Adams,"

Minicam Photography, September-October 1946
Time, June 2, 1947, "Camera v. Brush" (review of portfolio in *Fortune* of Paintings by Max Ernst, Jane Berlandina, David Fredenthal, Dong Kingman and photographs of National Parks by Ansel Adams).
U.S. Camera, Aug. 1955: "Interview with Three Greats" (Imogen Cunningham, Dorothea Lange, Ansel Adams).
Pollack, Peter, "Ansel Adams, Interpreter of Nature," *The Picture History of Photography,* New York: Abrams, 1958
Wright, Jack, "The Works and Ideas of Ansel Adams, FPSA," *PSA Journal, 1951 Annual*
Masclet, Daniel, "Trois Grandes Expositions Artistiques," *Photo-Cinéma* (Paris), December 1956
LaTour, I a, "West Coast Photography: Does It Really Exist?" *Photography* (London), June 1957
White, Minor, "Ansel Adams—Musician to Photographer," *Image,* February 1957
Weiss, Margot, "What Ansel Adams Teaches," *Popular Photography,* November 1961
"The Nature of Ansel Adams," *Pageant,* May 1962
MacDonnell, Kevin, "Polaroid Practice: One Subject, Six Photographers." (Portraits of Adams) *Photography* (London), October 1962
Vestal, David, "David in Adamsland," *Popular Photography,* December 1968
Cahn, Robert, "Ansel Adams, Environmentalist," *Sierra* (*Sierra Club Bulletin*), May/June 1979

Portfolios of Original Prints:

Parmelian Prints of the High Sierras 18 prints. Typography by the Grabhorn Press, San Francisco: Jean Chambers Moore, 1927
Portfolio One: In Memory of Alfred Stieglitz Foreword and 12 prints. Typography by the Grabhorn Press, San Francisco, 1948
Portfolio Two: The National Parks and Monuments Foreword and 15 prints. Typography by the Grabhorn Press, San Francisco, 1950
Portfolio Three: Yosemite Valley Foreword and 16 prints. Typography by the Grabhorn Press, San Francisco: Sierra Club, 1960
Portfolio Four: What Majestic Word In memory of Russell Varian Biographical sketch by Dorothy Varian. Foreword and 15 prints. Typography by Lawton Kennedy. Sponsored by the Varian Foundation. San Francisco: Sierra Club, 1963
Portfolio Five: Foreword by Nancy Newhall and 10 prints. Typography by Adrian Wilson. New York: Parasol Press, 1971

Portfolio Six: Foreword by Nancy and Beaumont Newhall and 10 prints. Typography by Adrian Wilson. New York: Parasol Press, 1974

Portfolio Seven: Foreword by Ansel Adams and 12 prints. Typography by Adrian Wilson. New York: Parasol Press, 1976

Films:

Ansel Adams, Photographer Directed by David Myers. Produced by Larry Dawson. Script by Nancy Newhall. Narration by Beaumont Newhall. Released 1957

Photography: The Incisive Art 5 films for Television in which Adams acts as protagonist. Directed by Robert Katz. Released 1959

Yosemite, Valley of Light Directed by Tom Thomas. Adams served as consultant and protagonist. Released 1957

MAJOR EXHIBITIONS:

ONE-MAN:

1931: Smithsonian Institution, Washington, D.C. 1932: M. H. de Young Memorial Museum, San Francisco. 1933: Delphic Studios, New York. 1934: Albright Art Gallery, Buffalo; Yale University. 1936: An American Place, New York; Katharine Kuh Gallery, Chicago; Arts Club, Washington. 1938: University of California, Berkeley. 1939: San Francisco Museum of Art. 1944: Museum of Modern Art, New York. 1946: Santa Barbara Museum. 1950: Pasadena Art Institute. 1951: Art Institute of Chicago. 1952: George Eastman House, Rochester, New York; exhibition circulated by Smithsonian Institution. 1956: photokina, Cologne. 1957: University of Hawaii. 1961: American Federation of Arts, Carmel. 1963: M. H. de Young Memorial Museum, San Francisco. 1967: Museum of Fine Arts, Boston. 1970 and 1972: Witkin Gallery, New York. 1972: Philadelphia Print Club. 1972: San Francisco Museum of Modern Art. 1974: Metropolitan Museum of Art, New York. 1976: University of Arizona Museum of Art, Tucson. 1979: *Ansel Adams and the West,* The Museum of Modern Art, New York; exhibition subsequently circulated by the Museum in the United States, through 1981.

GROUP:

1932: *Group f/64,* M. H. de Young Memorial Museum, San Francisco. 1937: *Photography, 1839-1937,* The Museum of Modern Art, New York. 1939: *Seven American Photographers,* The Museum of Modern Art, New York. 1944: *Art in Progress,* The Museum of Modern Art, New York. 1947: *The National Parks* (with paintings by Max Ernst, Jane Berlandina, Dong Kingman, David Fredenthal), Downtown Gallery, New York. 1951: *Contemporary Photography,* Contemporary Arts Museum, Houston, Texas. 1952: *Diogenes with a Camera II.* The Museum of Modern Art, New York. *Subjektive Fotografie II.* Staatliche Schule für Kunst und Handwerk, Saarbrücken, Germany. 1959: *Photography at Mid Century,* George Eastman House, Rochester, New York. 1962: *Ideas in Images,* Worcester (Massachusetts) Art Museum. 1963: *The Photographer and the American Landscape.* The Museum of Modern Art, New York. 1974: *Photography in America,* Whitney Museum, New York. 1975: *The Land,* Victoria and Albert Museum, London. 1978: *The Collection of Alfred Stieglitz,* Metropolitan Museum of Art, New York.

EXHIBITIONS ORGANIZED BY ANSEL ADAMS:

1940: *Pageant of Photography,* Golden Gate Exposition, San Francisco; *Sixty Photographs* (with Beaumont Newhall) The Museum of Modern Art, New York. 1942: *Photographs of the Civil War and the American Frontier.* The Museum of Modern Art. 1954: *This is the American Earth* (with Nancy Newhall) Sierra Club, Yosemite, and California Academy of Sciences; exhibition circulated in the United States by the Smithsonian Institution and overseas by the United States Information Service. 1957: *I Hear America Singing* (assisting Nancy Newhall) for the United States Information Service: Kongresshalle, Berlin; duplicate for Tokyo. 1959: *The Story of a Winery* (with Pirkle Jones); circulated by the Smithsonian Institution.

COLOPHON:
Design: Liliane De Cock
Type: Latine and Latine Italic
Printing: Rapoport Printing Corp.
Two Impression Lithography
Binding: A. Horowitz & Son

Original material for chronology and bibliography by courtesy of Nancy Newhall as compiled for exhibition monograph, *The Eloquent Light,* 1963.

Plates 1, 2 and 7 have been reproduced from original Parmelian prints.

Plate 87, from Portfolio V, 1971, published by Parasol Press, New York

Plates 103, 104, 107, 108 and 110 have been reproduced from original Polaroid Land prints.

Plates 92, 106, 112 and 113 have been reproduced from prints made from Polaroid Land Type 55 P/N negatives.